# CANADA COUNTS

## A
## CHARLES PACHTER
## COUNTING BOOK

Cormorant Books Inc.

 Canada Council    Conseil des Arts
for the Arts      du Canada

The publisher gratefully acknowledges the support of the
Canada Council for the Arts and the Ontario Arts Council
for its publishing program. We acknowledge the financial
support of the Government of Canada through the Book
Publishing Industry Development Program (BPIDP) for our
publishing activities.

Printed and bound in Canada

Library and Archives Canada Cataloguing in Publication

Pachter, Charles, 1942–
Canada Counts: a Charles Pachter counting book.

Includes bibliographical references.
ISBN 978-1-897151-52-5

1. Counting — Juvenile literature. 2. Canada — Juvenile
literature.  I. Title.

QA113.P32 2009    j513.2'11    C2009-903871-4

Editor: Marc Côté
Cover design: Angel Guerra/Archetype
Cover image: Detail from *Moosemanoe*, Charles Pachter,
   2009
Text design: Tannice Goddard/Soul Oasis Networking
Printer: Manufactured by Friesens Corporation, in Altona,
   MB, Canada in September 2009. Job #48412.

Cormorant Books Inc.
215 Spadina Avenue, Studio 230, Toronto, ON Canada M5T 2C7
www.cormorantbooks.com

FSC  **Mixed Sources**
Cert no. SW-COC-001271
© 1996 FSC

*To my great nephews and nieces*
*Harrison, Jesse, Ryan, Sage, Sara, and Xander,*
*and to Eleanor LeFave for her inspiring guidance.*

**1**

One moose swimming and one man in one canoe.

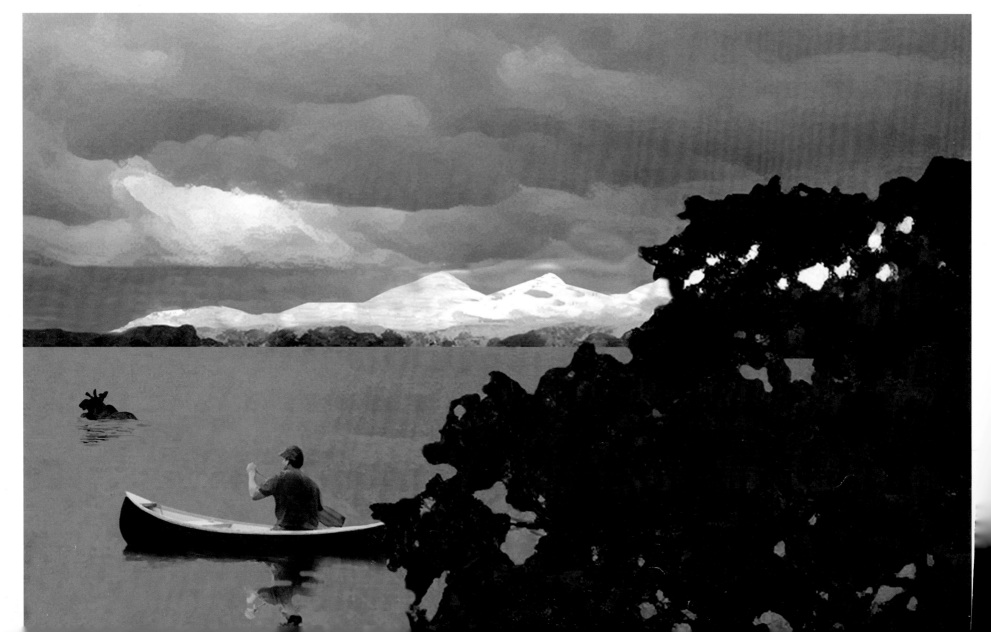

One noble
caribou.

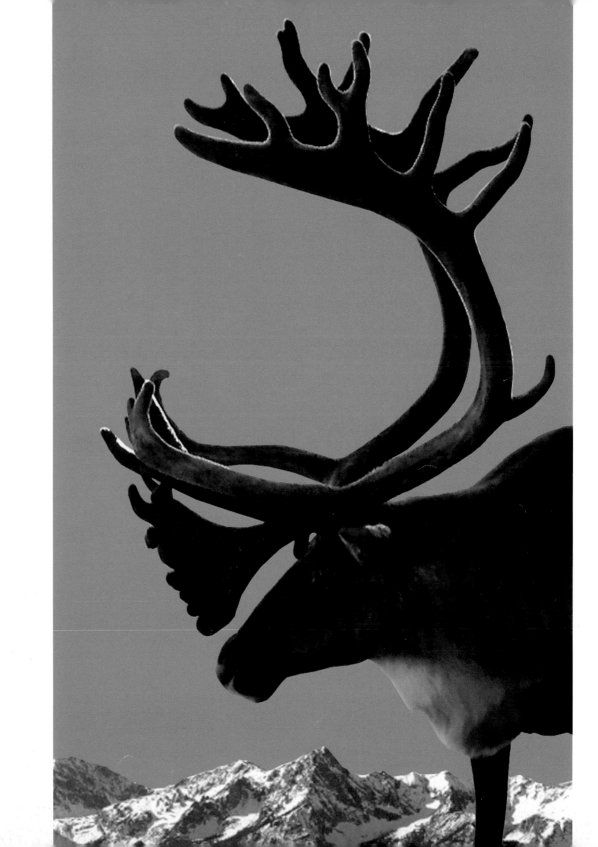

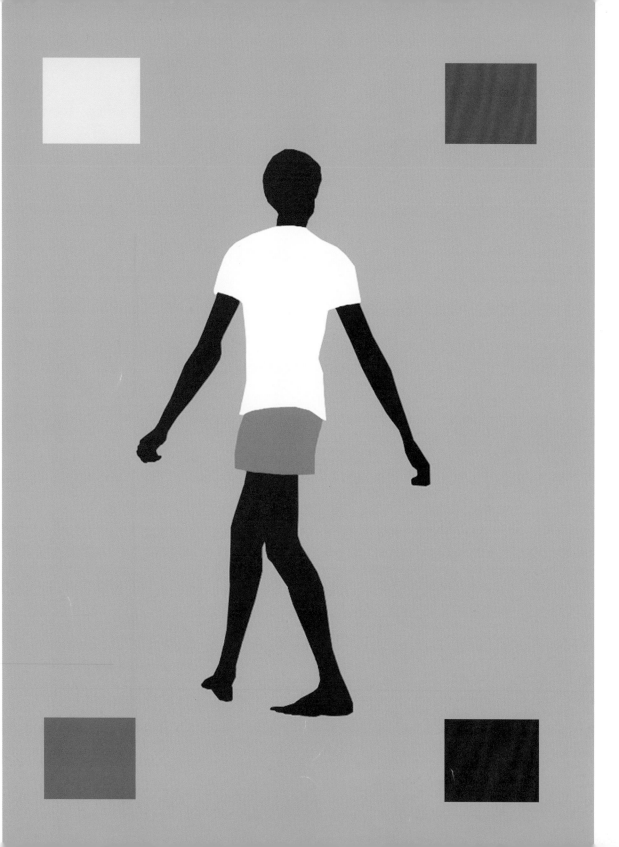

One man walking.

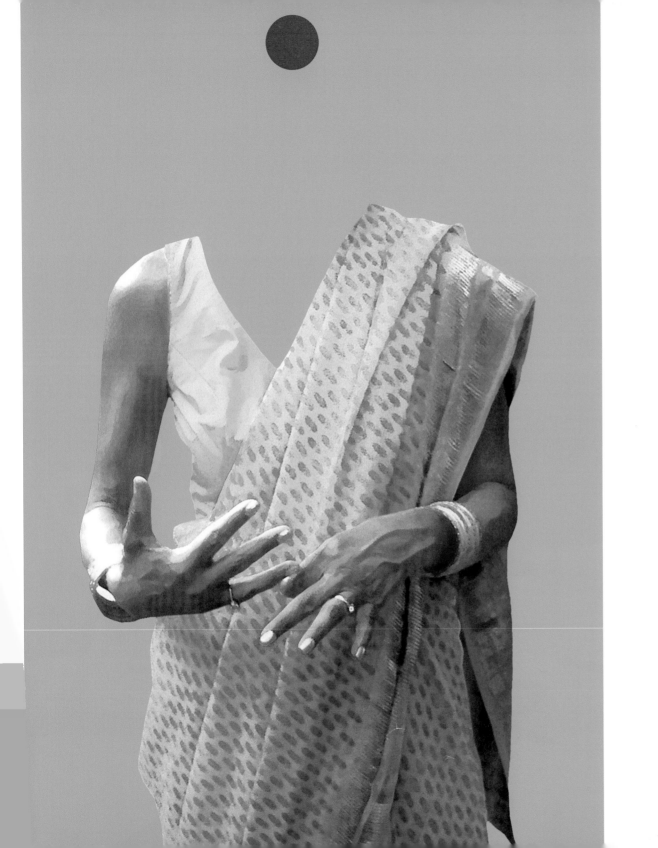

One woman in a sari.

Two friends pausing beside the lake.

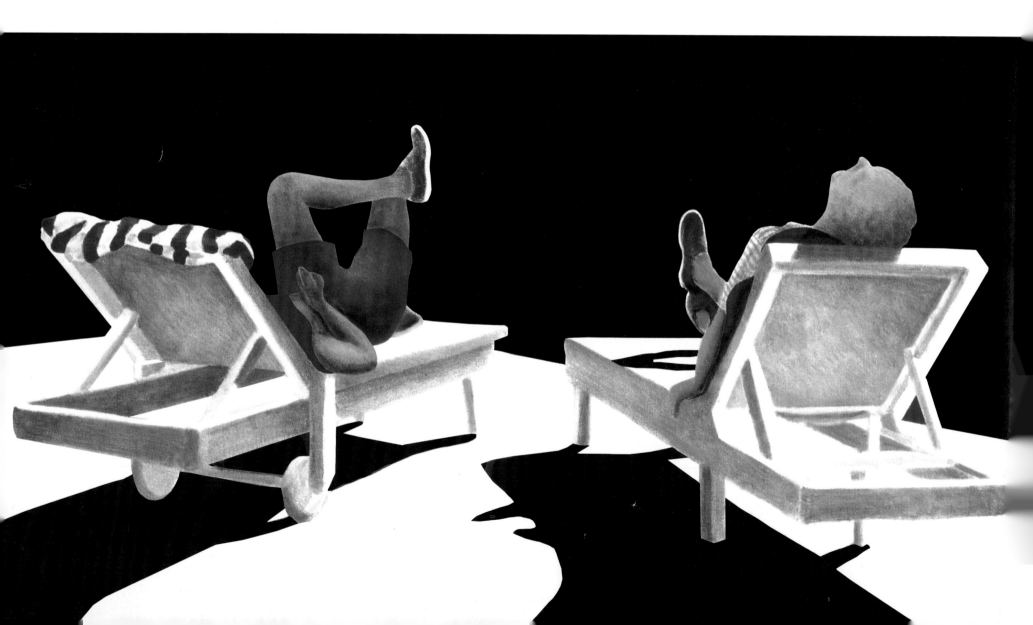

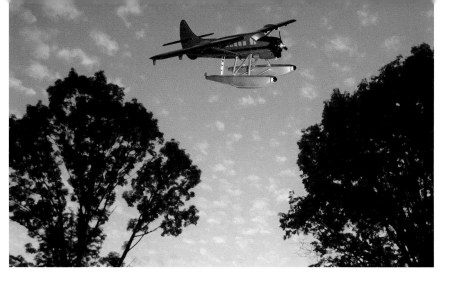

The beaver and the otter are animals, it's true
but did you know they are airplanes, too?
They are Canadian through and through.
They fly and bounce and what really counts:
they opened up our country, and that amounts
to a whole lot of pride, and a fantastic ride!

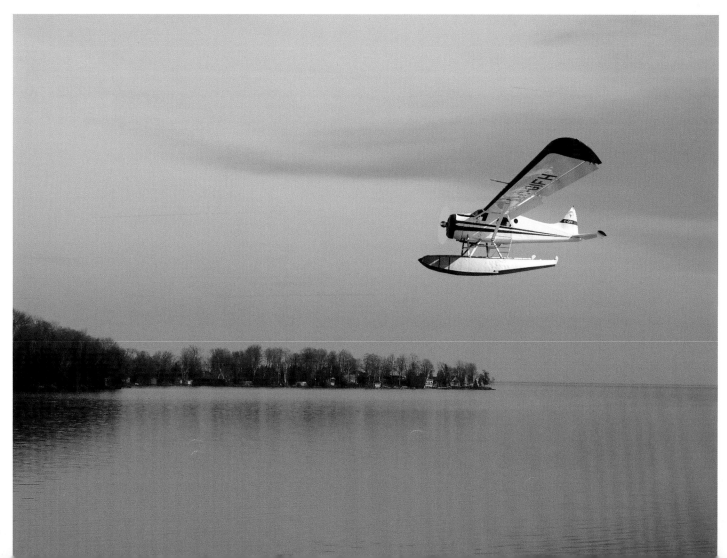

**3**

Here are three portraits of Ruth.
She is my friend and that's the truth.

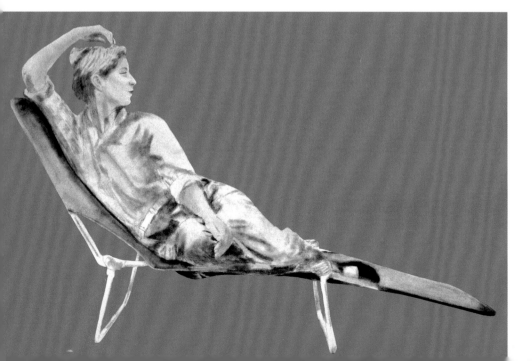

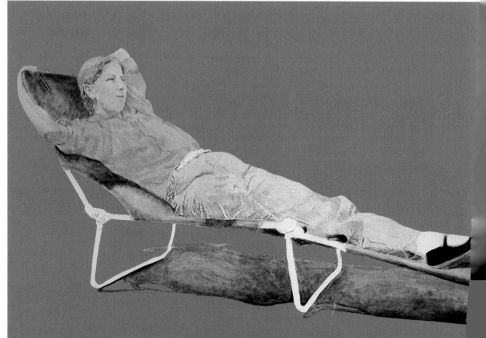

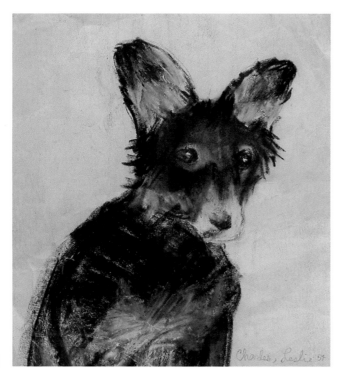

Leslie

Cheyenne

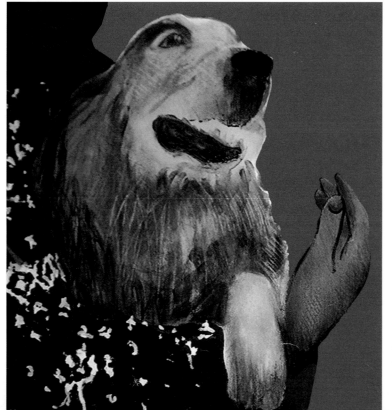

Elvis

And here are three dog portraits that I drew:
Leslie, Elvis, and Cheyenne, too.
It's fun painting dogs, they are so loyal,
whether in acrylic, pastel, or oil.

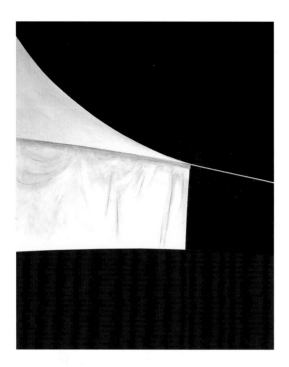
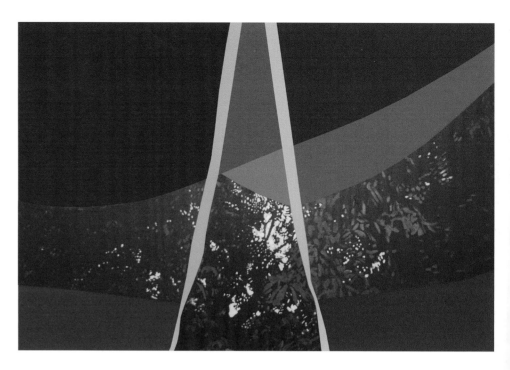
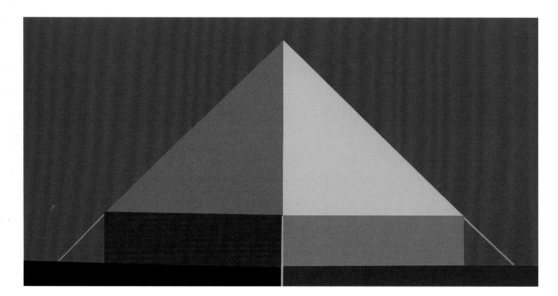
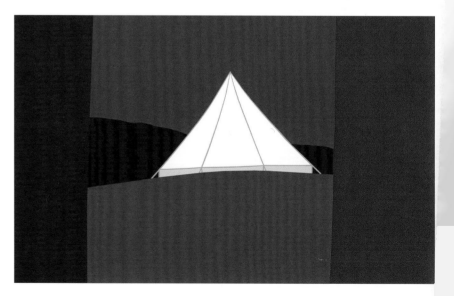

Four colourful tents.

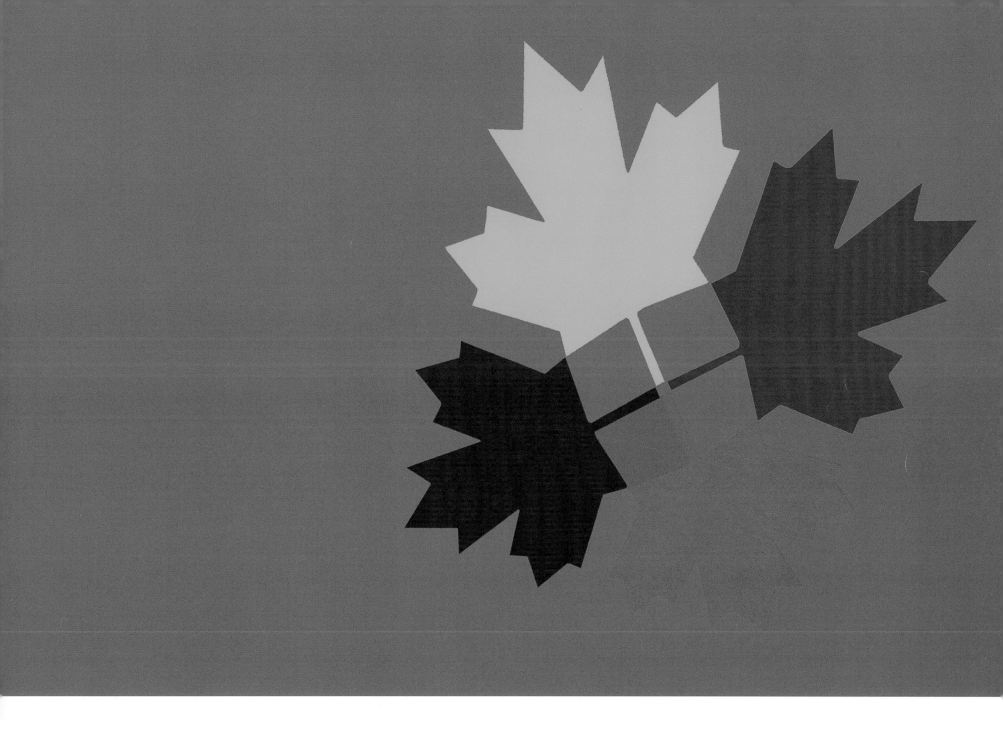

Four leaves for four seasons.

Winter, spring, summer, fall.

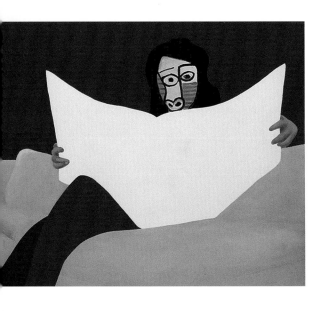
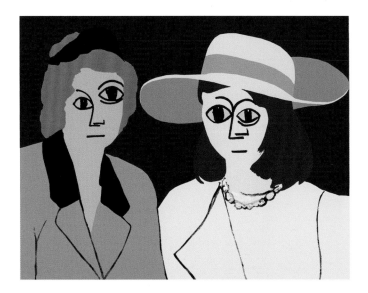
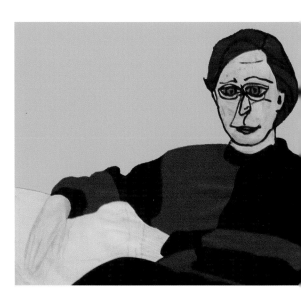

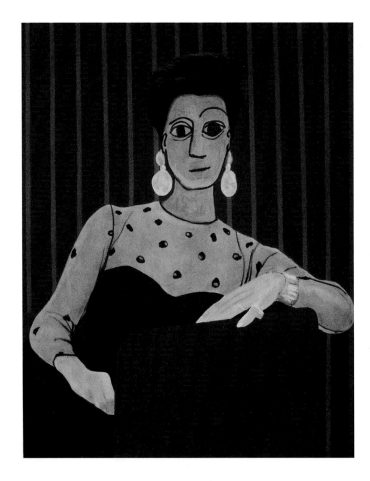

Five women with funny faces.

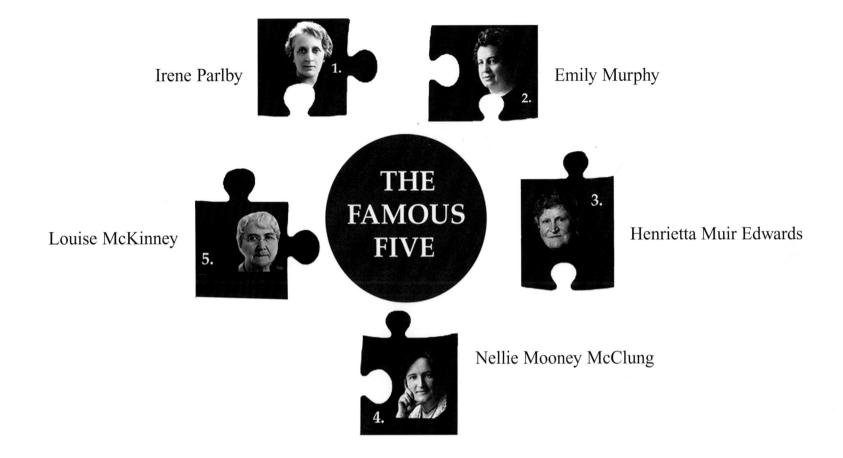

Irene Parlby 1.

Emily Murphy 2.

THE FAMOUS FIVE

Louise McKinney 5.

Henrietta Muir Edwards 3.

Nellie Mooney McClung 4.

PERSONS!

Many years ago, they sought to change the law
so women could be persons, just like men
and so women could be senators, just like men.
A new law was made, groundbreaking then,
that made all women persons. Ever since then
not only are they persons and senators, too,
they often do it better than the men — so what else is new.

Six Nanaimo bars.

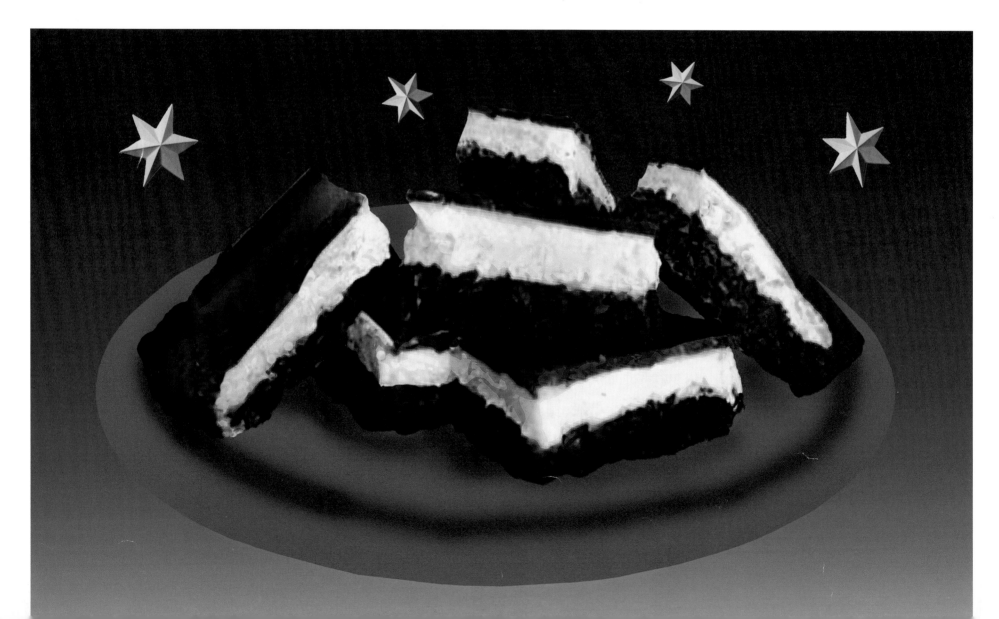

Six friends chatting
in two groups of three,
or three groups of two.
What do you see?

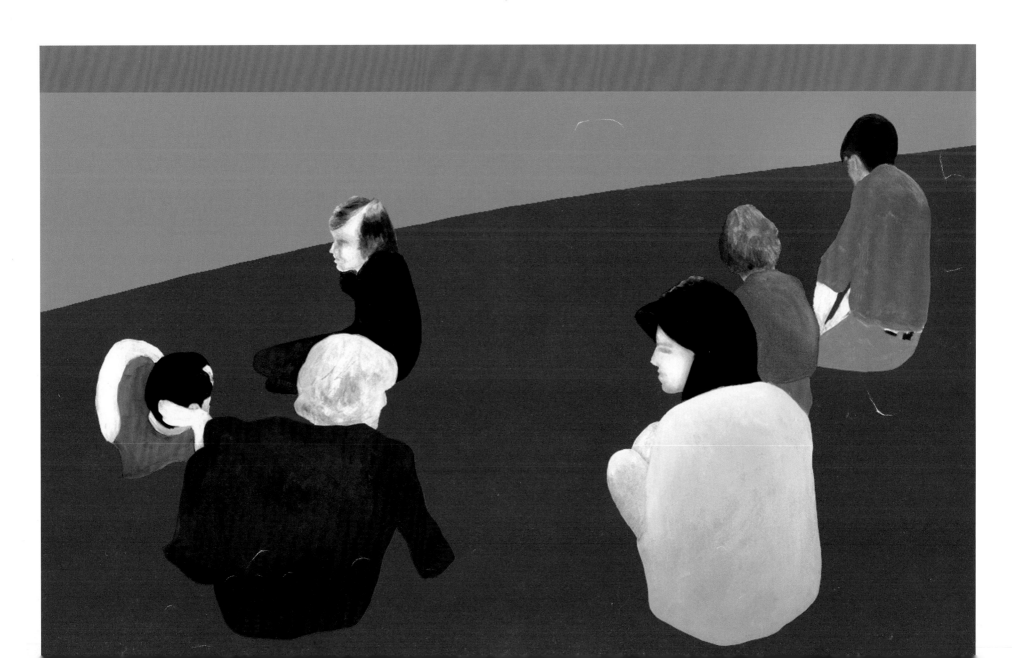

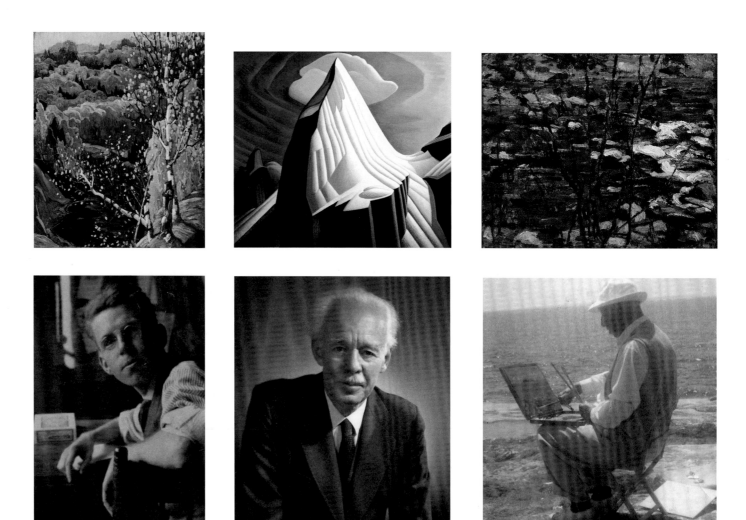

Franklin Carmichael    Lawren S. Harris    A.Y. Jackson

Say C  H  J  J  L  M  V.
They taught us with fresh eyes to see
the natural beauty of our country.
They were seven talented guys
who painted our lakes, woods, and skies.

Frank Johnston          Arthur Lismer          J.E.H. Macdonald          Frederick Varley

Their paintings are a hint of heaven.
We know them as the Group of Seven.

Can you say all their names?

**8**

Eight barns standing tall in the fields.

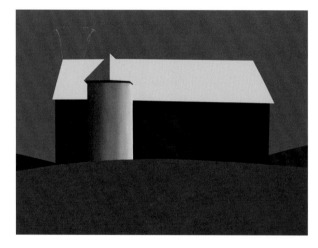
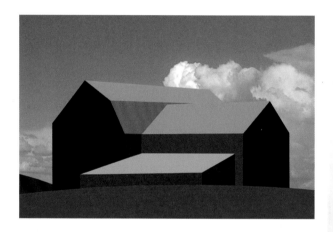
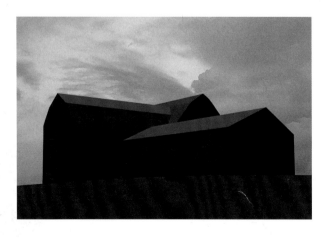
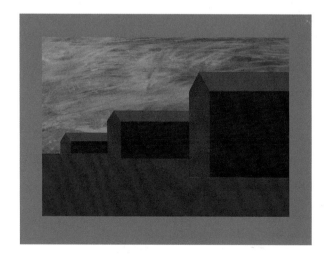
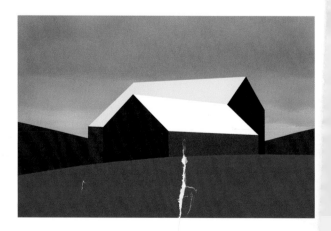

Eight square dancers moving
east, west, south, and north.
They join hands together
and doh-see-doh back and forth.

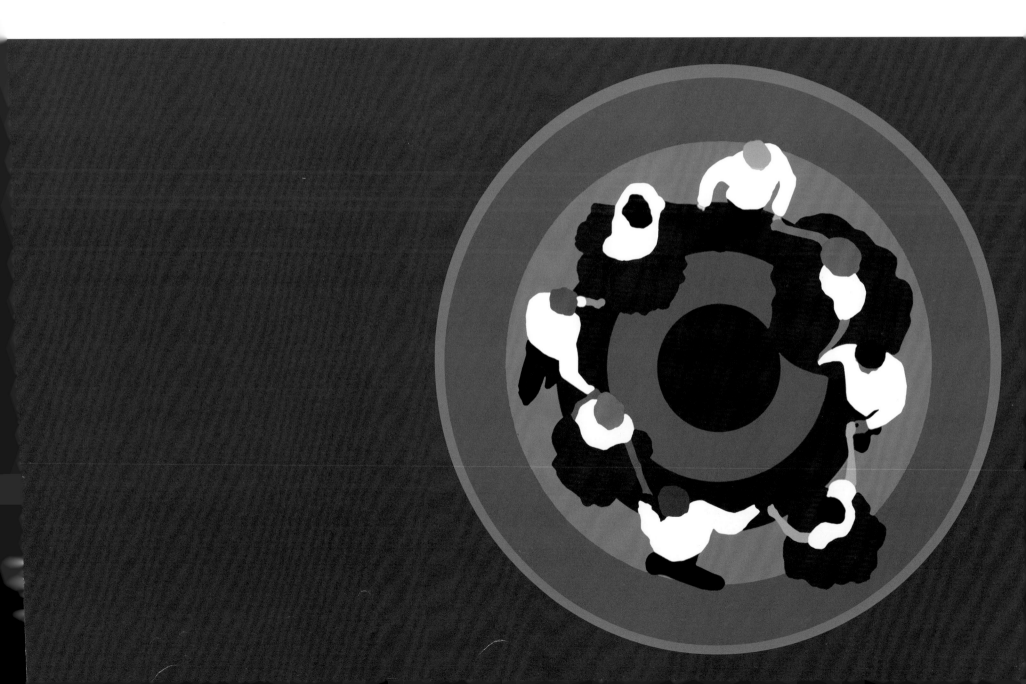

**9**

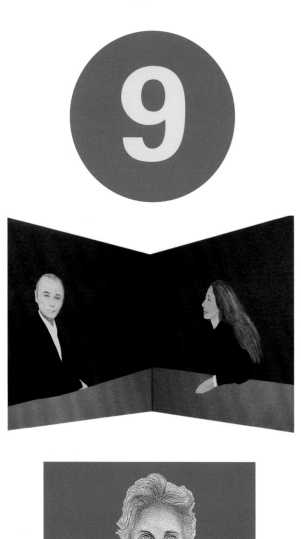

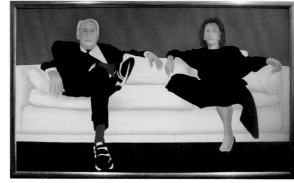

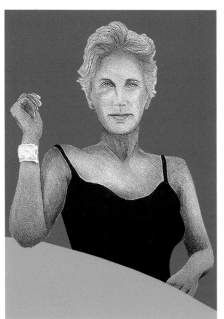

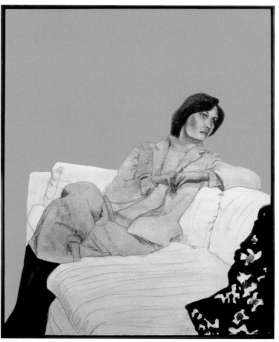

Portraits are an opportunity for everyone to see a person's personality!

Nine judges supreme.

Of our courtly crop, they are the cream.

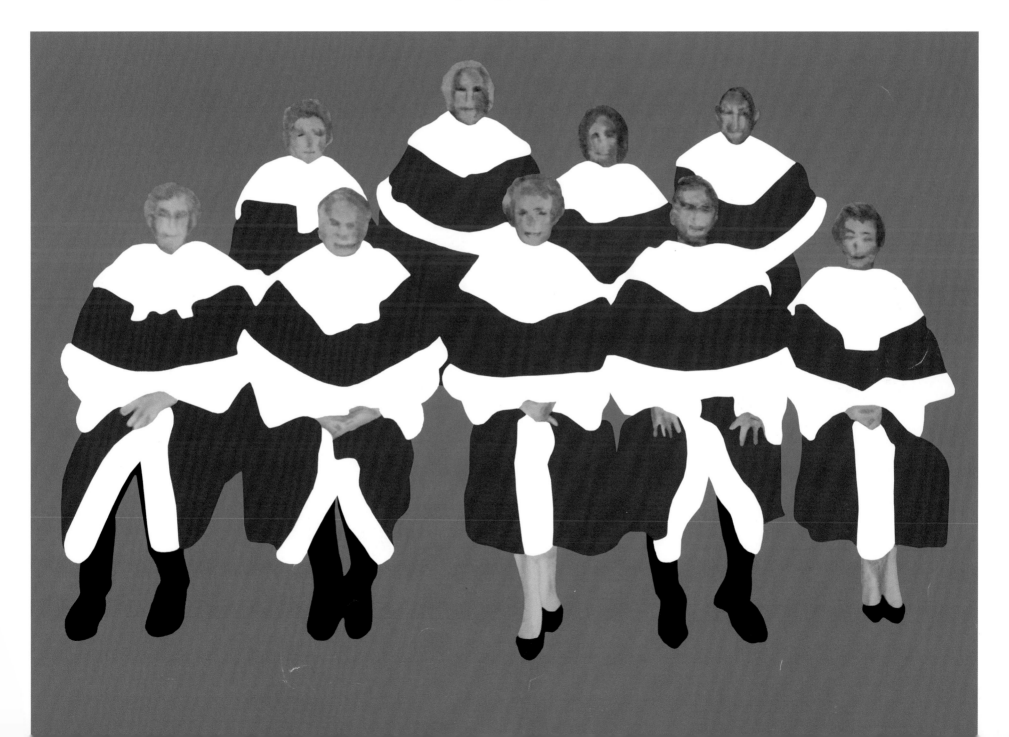

**10**

Ten Canadian flags in a row.

O

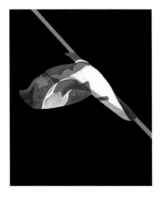

Ca -

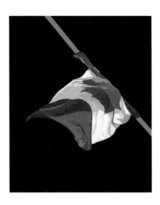

na -

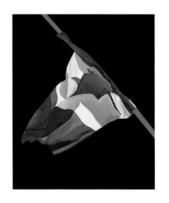

da!

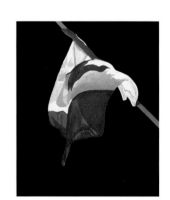

Our

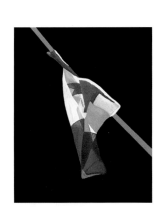

home

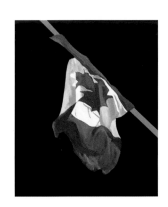

and

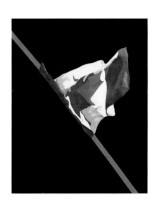

na  -

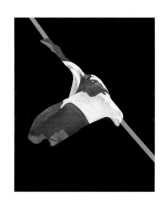

tive

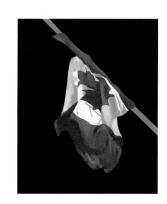

land!

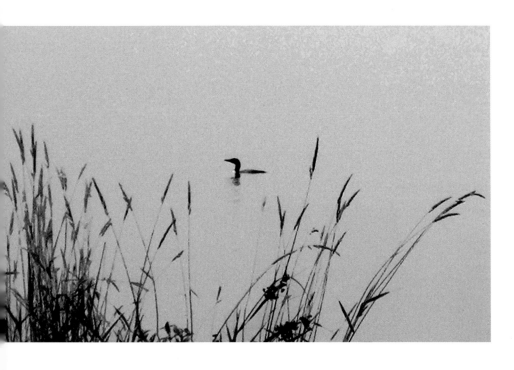

What a boon to see a loon
under the moon, at dawn or noon.
Or better still to hear one croon.

Suddenly three more appear.
Black and white, white and black.

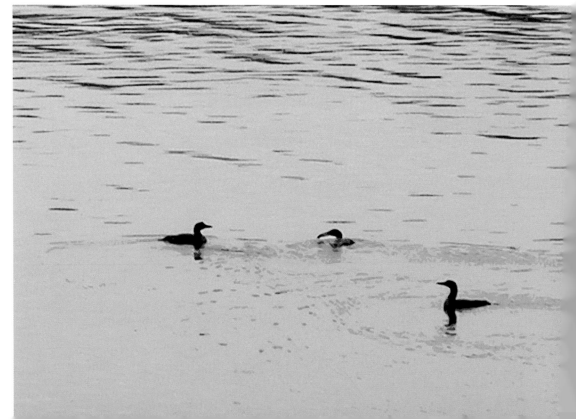

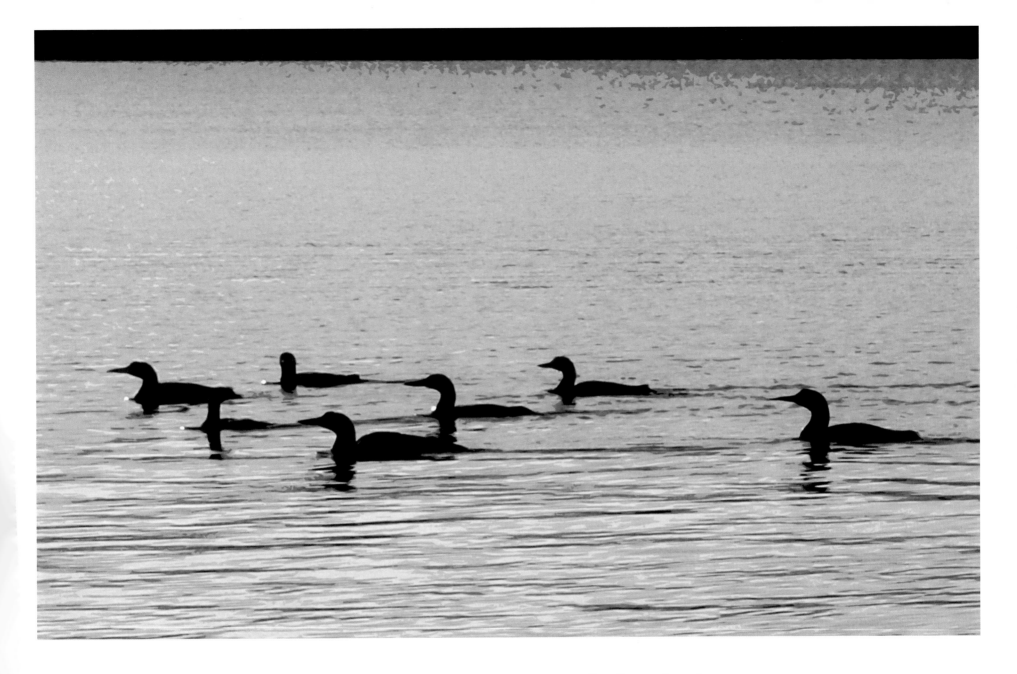

Here come seven more, not too far from the shore.

One loon plus three loons now equal four.

And with these seven, that makes eleven.

Now that's a record loonie score!

12

Twelve famous explorers

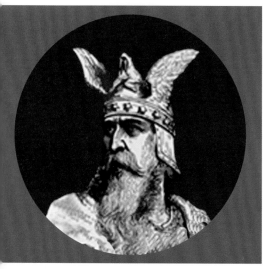

Leif Eriksson

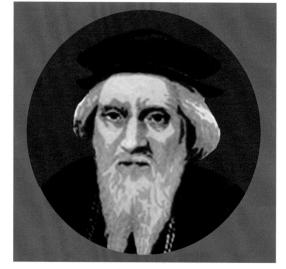

John Cabot

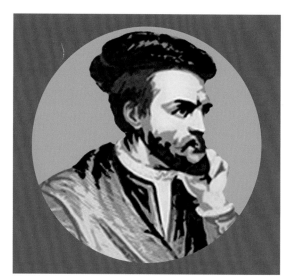

Jacques Cartier

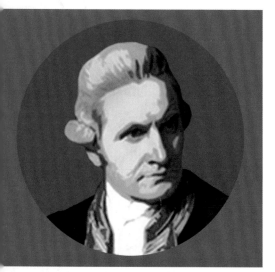

James Cook

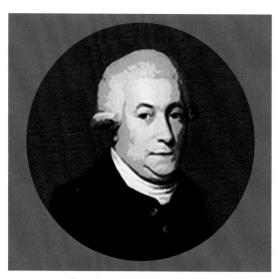

George Vancouver

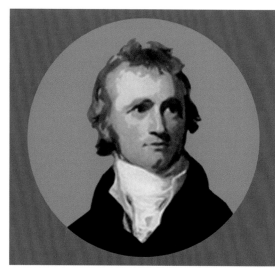

Alexander Mackenzie

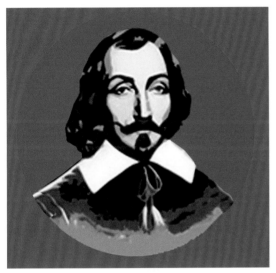

Samuel de Champlain

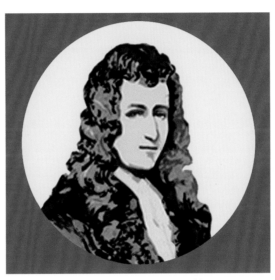

Robert de la Salle

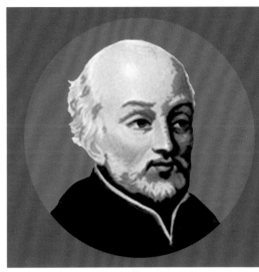

Pierre de Charlevoix

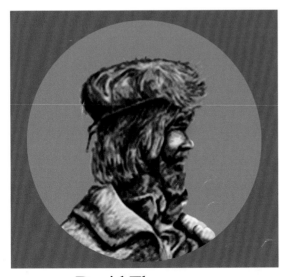

David Thompson

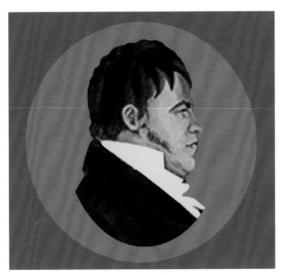

Simon Fraser

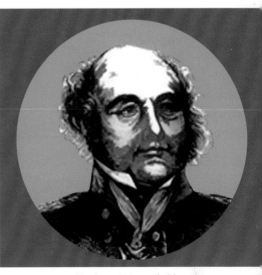

John Franklin

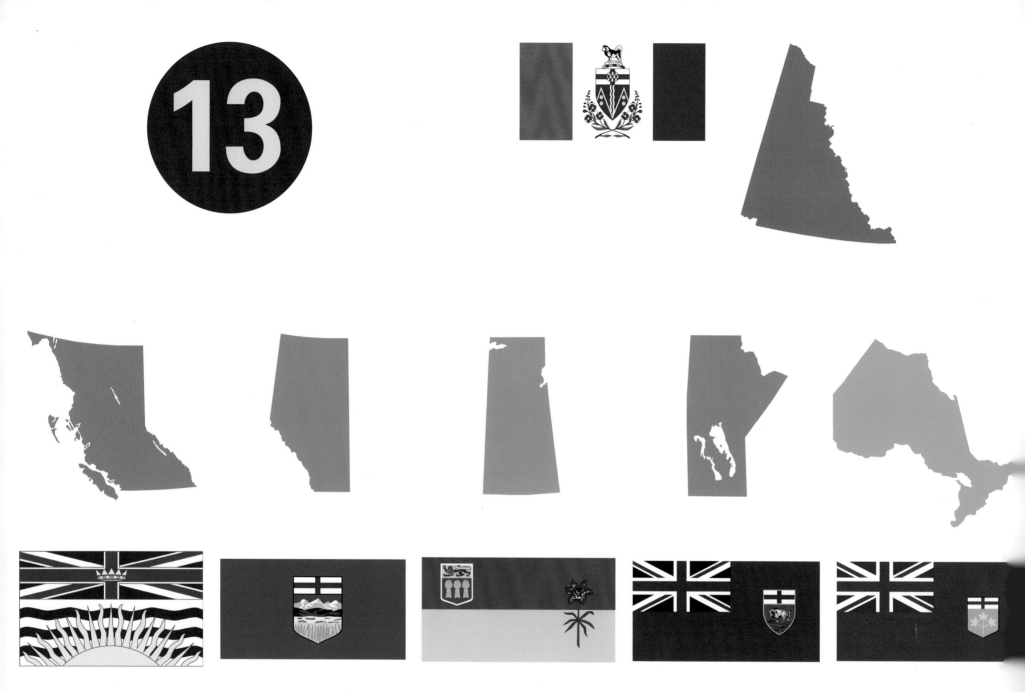

Ten provinces and three territories make a total of thirteen.

Each has its own flag.

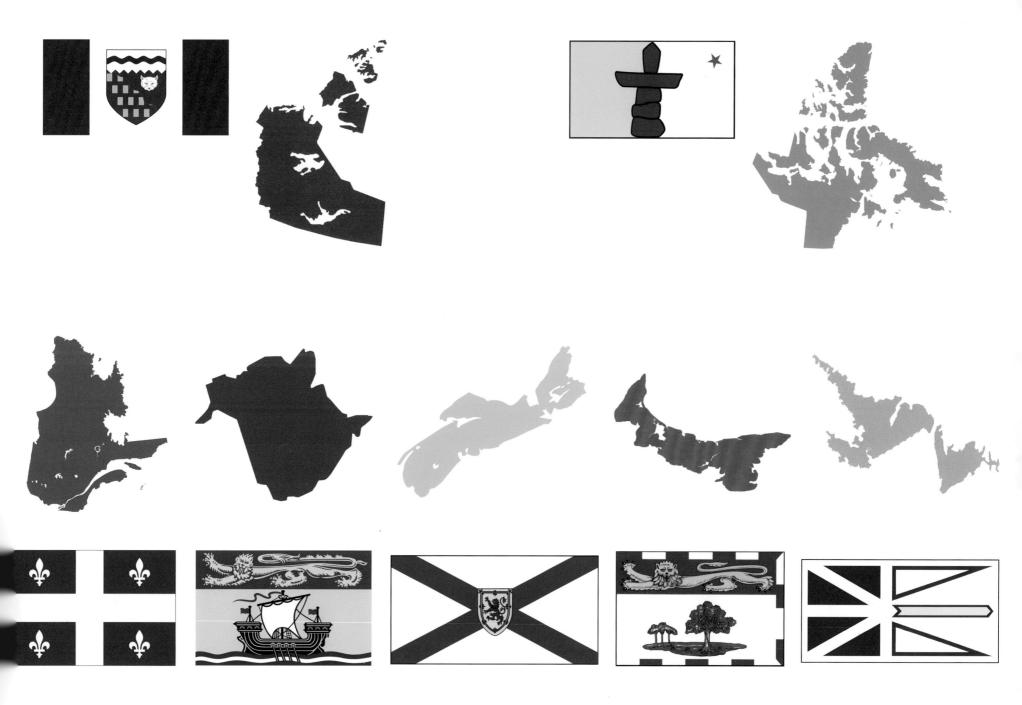

Which flag goes with which province or territory?

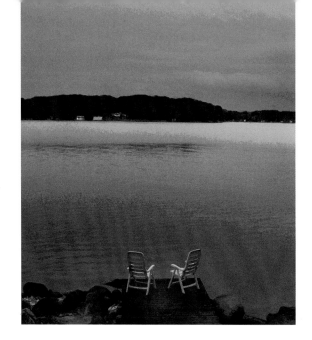

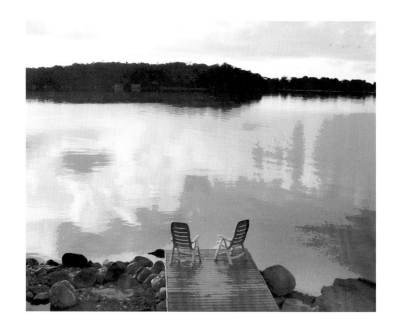

**14**

Seven pictures of two chairs
at twilight, dawn, and noon.
In the morning, in the evening,
and in the afternoon.

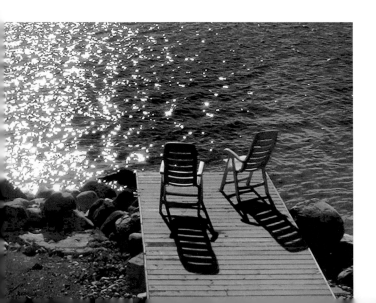

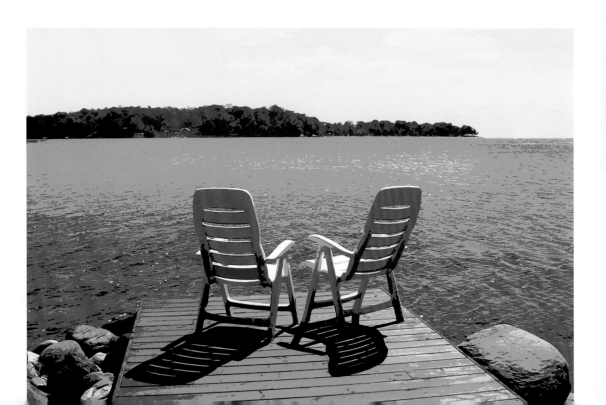

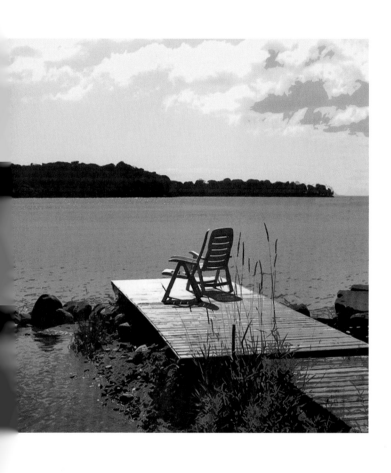
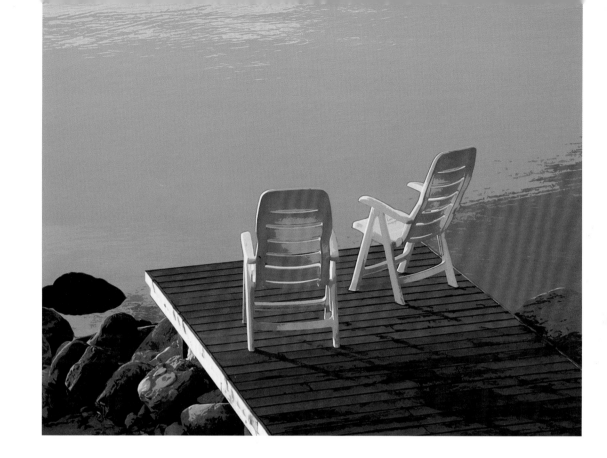
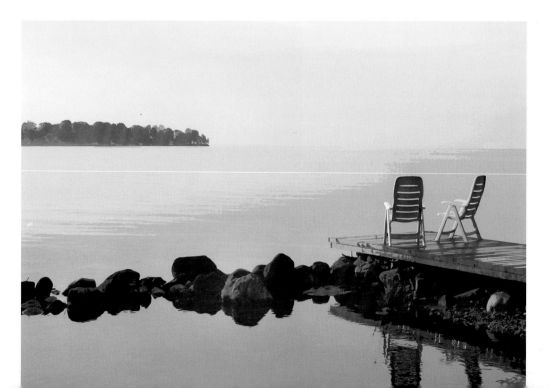

**15**

Fifteen purple martins
nesting at home.

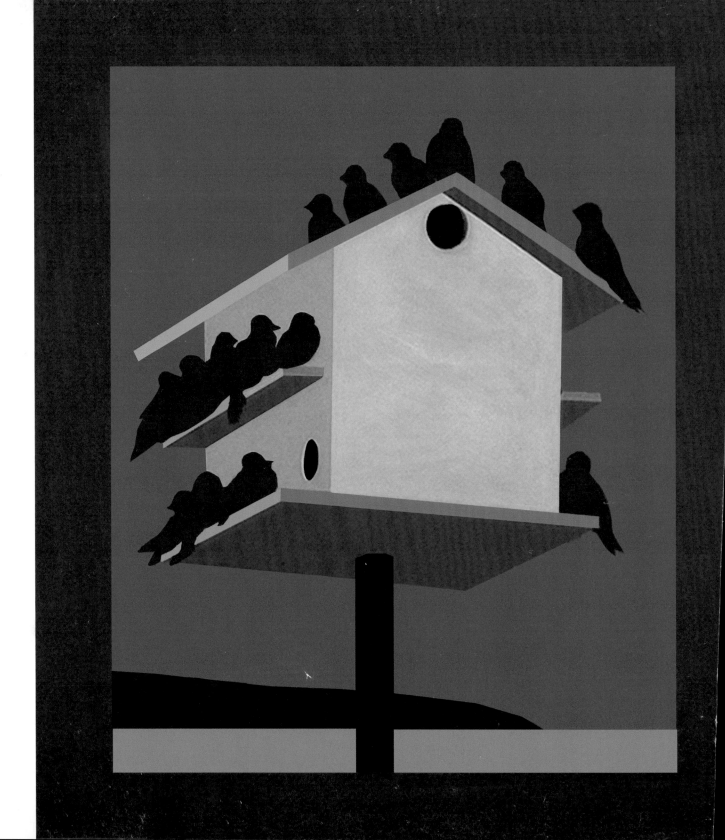

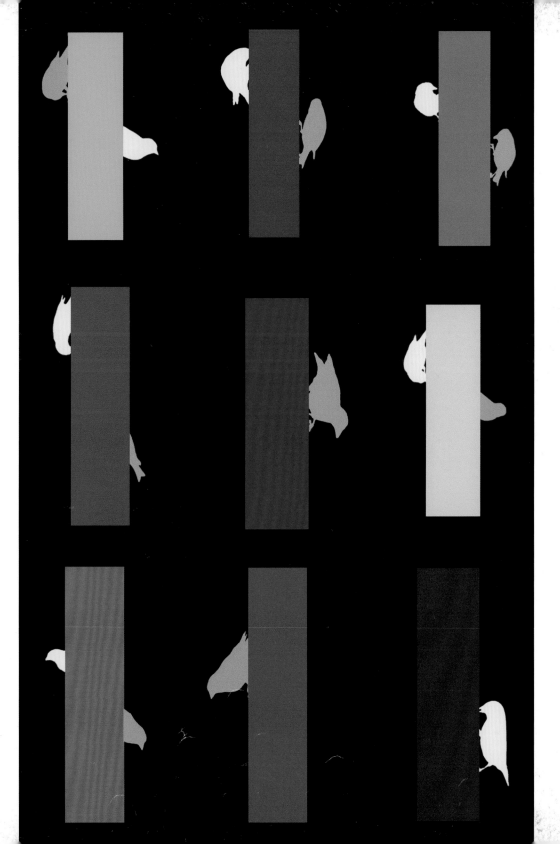

Fifteen finches
flitting around the feeder.
One flew down,
fluttered, fed, flew off.
Another one alit,
flitted, fed, and fled.
A few others flew too,
following the leader,
flitting and fluttering
and feeding at the feeder.

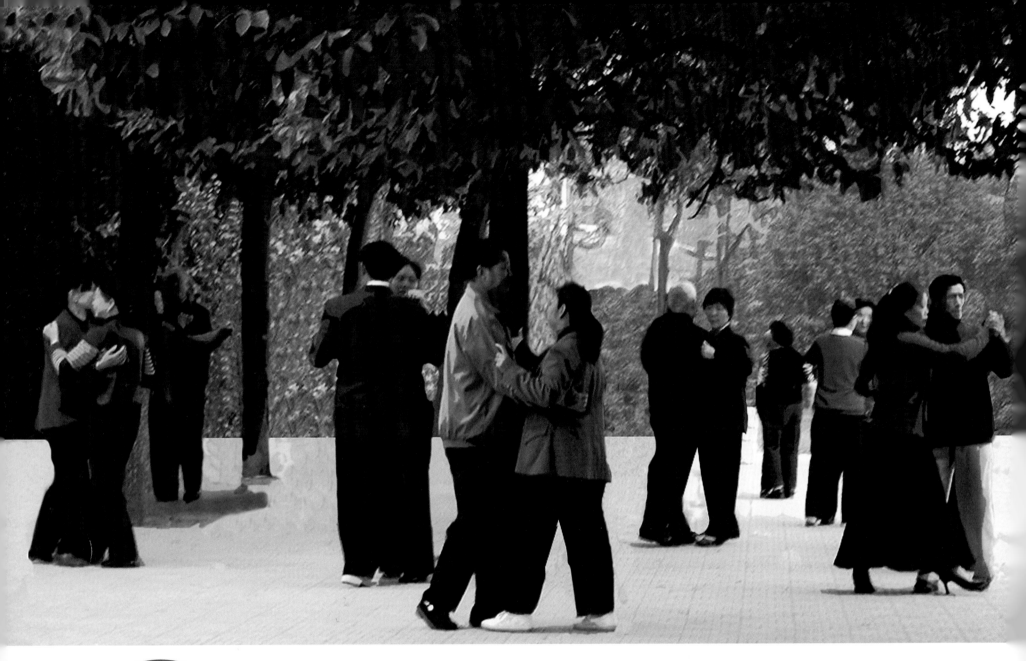

Sixteen dancers in the park.

Seventeen freshly husked cobs of corn, golden in the sun.

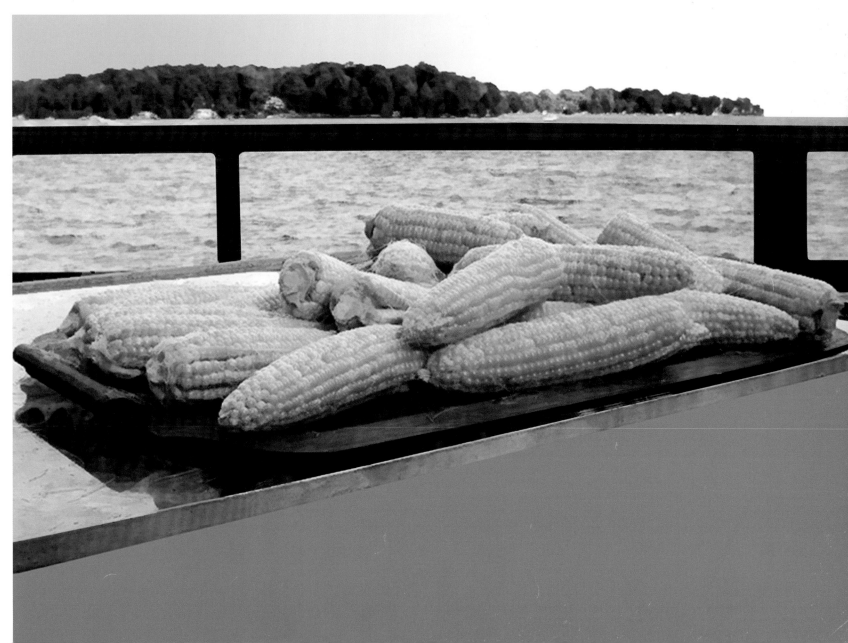

A still life is a visual treat,
showing fruit and vegetables
good enough to eat.

Here are three still lifes of
red peppers, apples, and grapefruit.

How many are there in each bowl?
What is the total?

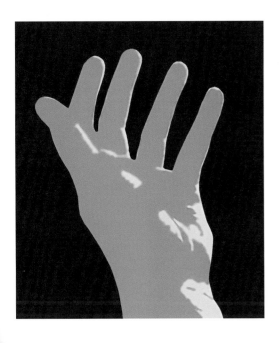

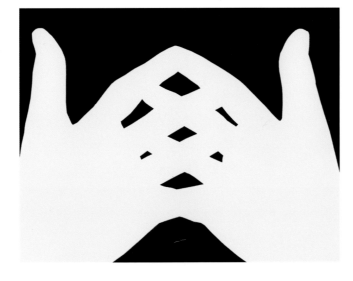

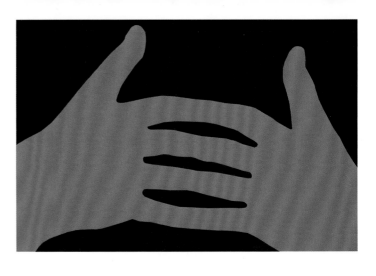

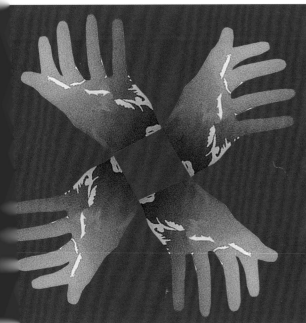

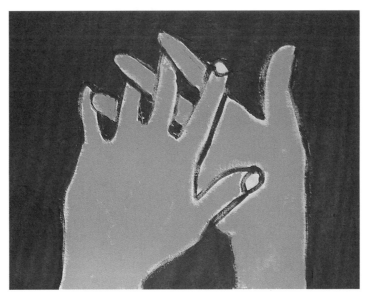

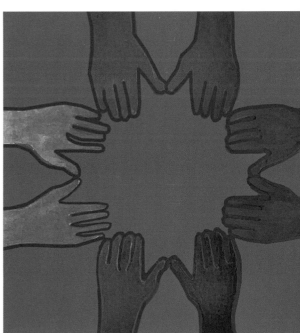

**19**

Four fingers and one thumb make up a hand.

One hand is nice, but two are grand.

Patterns can be made by shaping your hands

into arcades and emblems and signals and strands.

**20** Twenty hay bales for the cattle to eat.

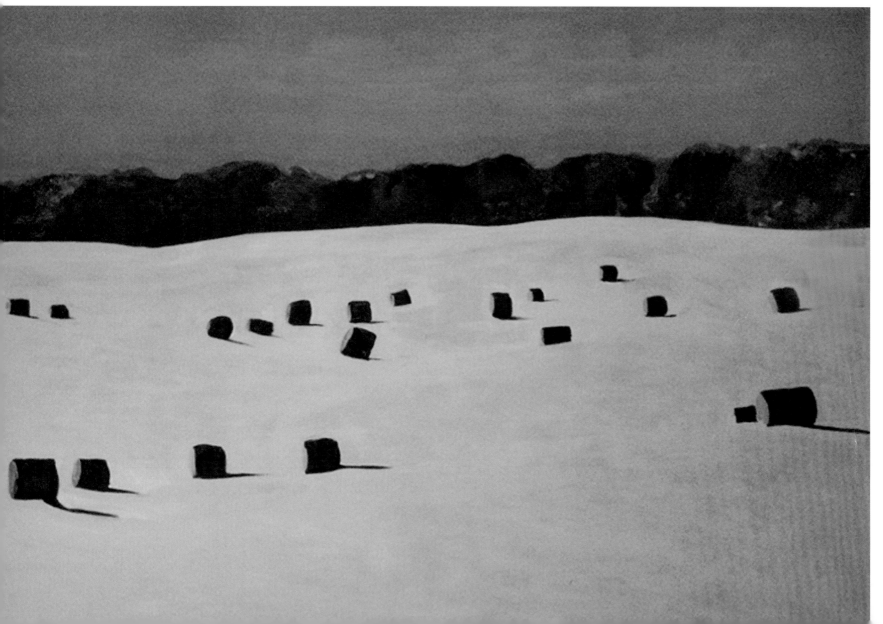

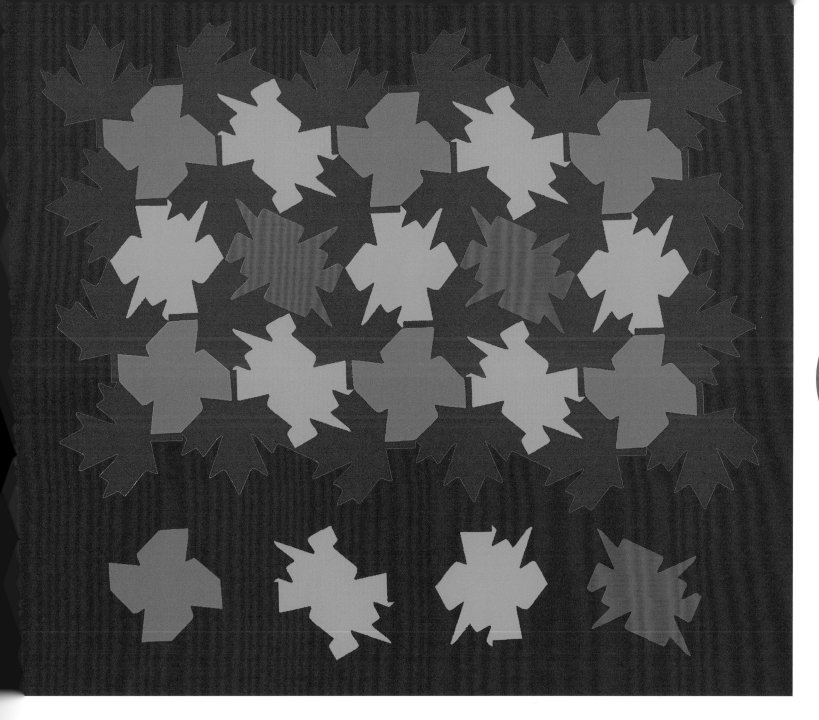

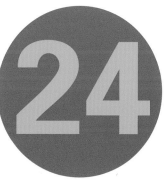

**24**

Twenty-four
maple leaves
arranged in rows
make many patterns,
like stars and bows.

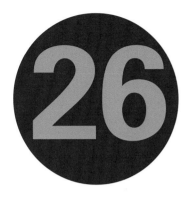

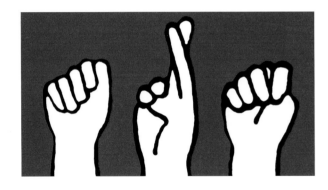

Twenty-six hand signs.

Each is a letter of the alphabet.

What does the

three-letter word spell?

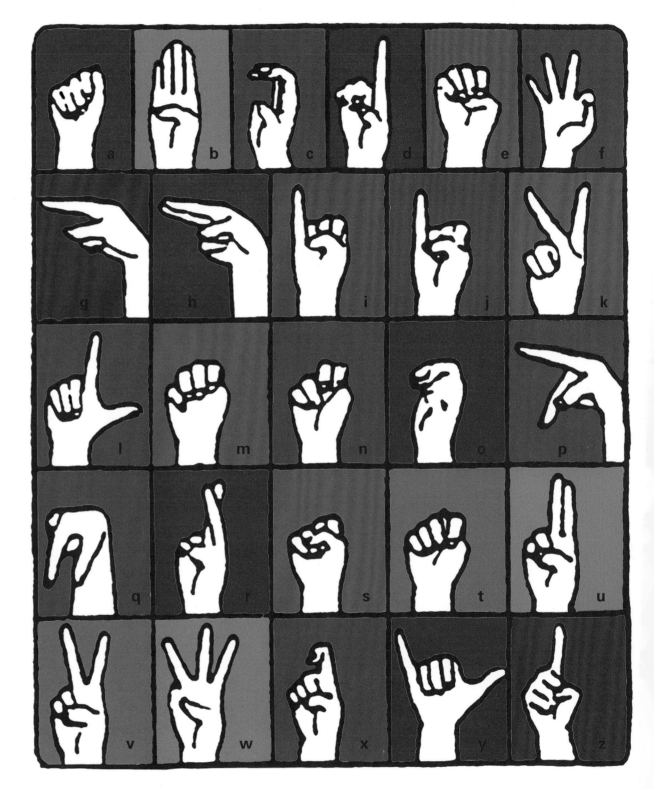

**29**

It's not so easy to explain
how caribou cross the northern plain.
Hundreds and thousands in a row,
over the tundra, ice and snow.

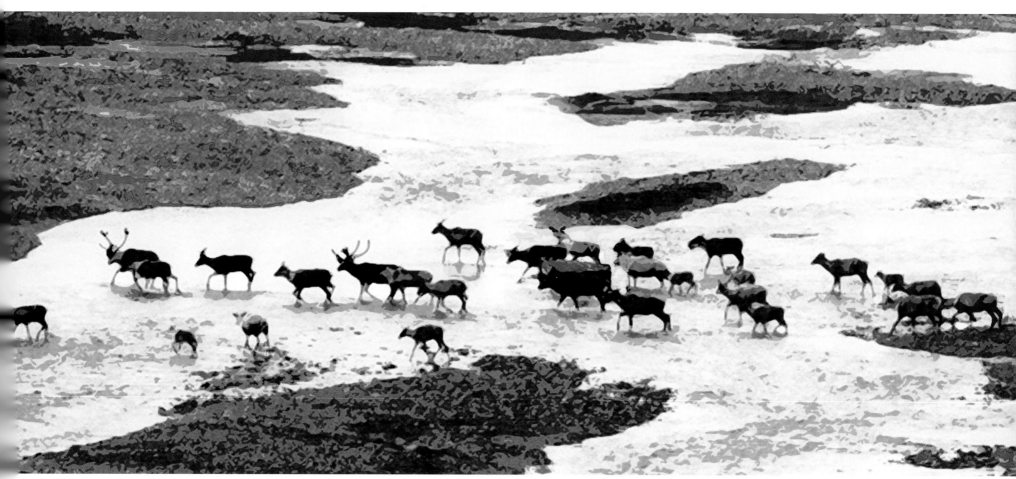

**37**

After patient consideration and much deliberation,
thirty-seven Fathers of Confederation
decided it was time to found a nation.

With imagination and motivation
they envisioned a new civilization
built on innovation and inspiration.

This decision was met with jubilation
by the larger population, who joined in the celebration
of the creation of the new Canadian nation.

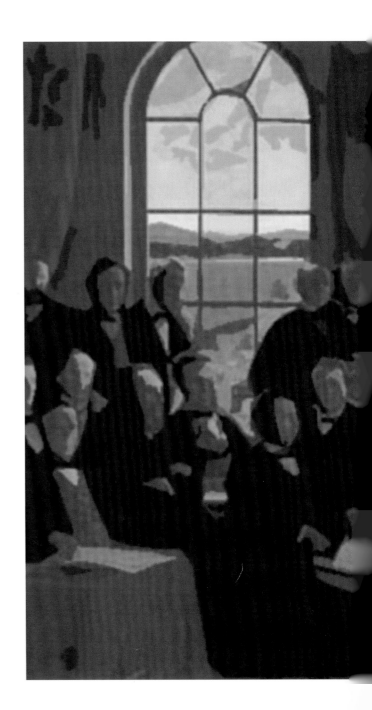

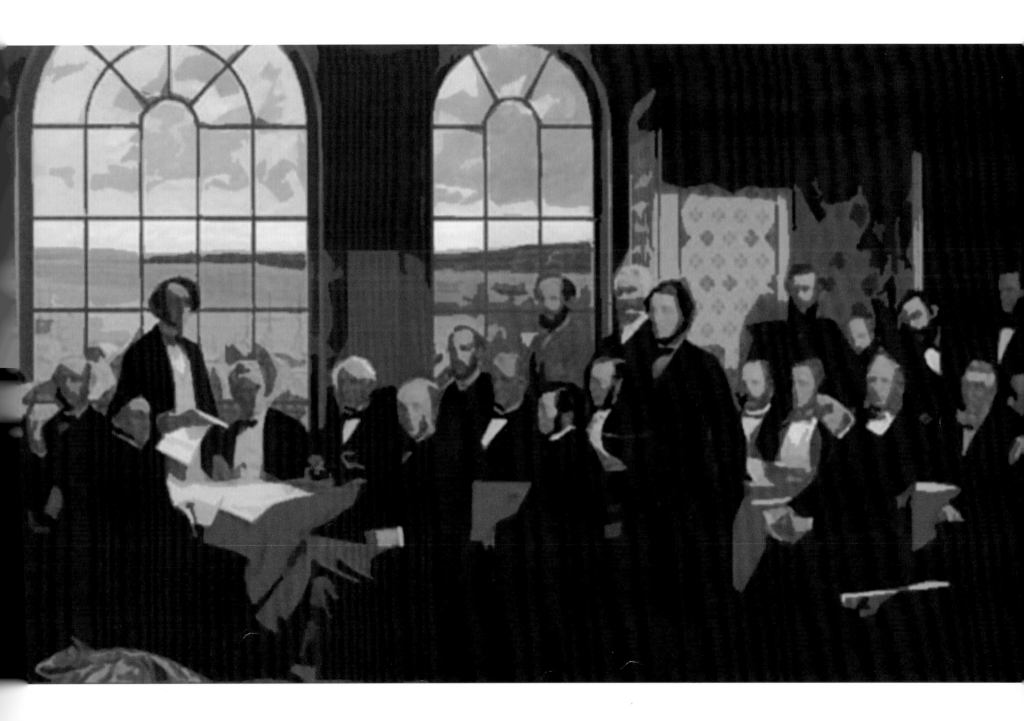

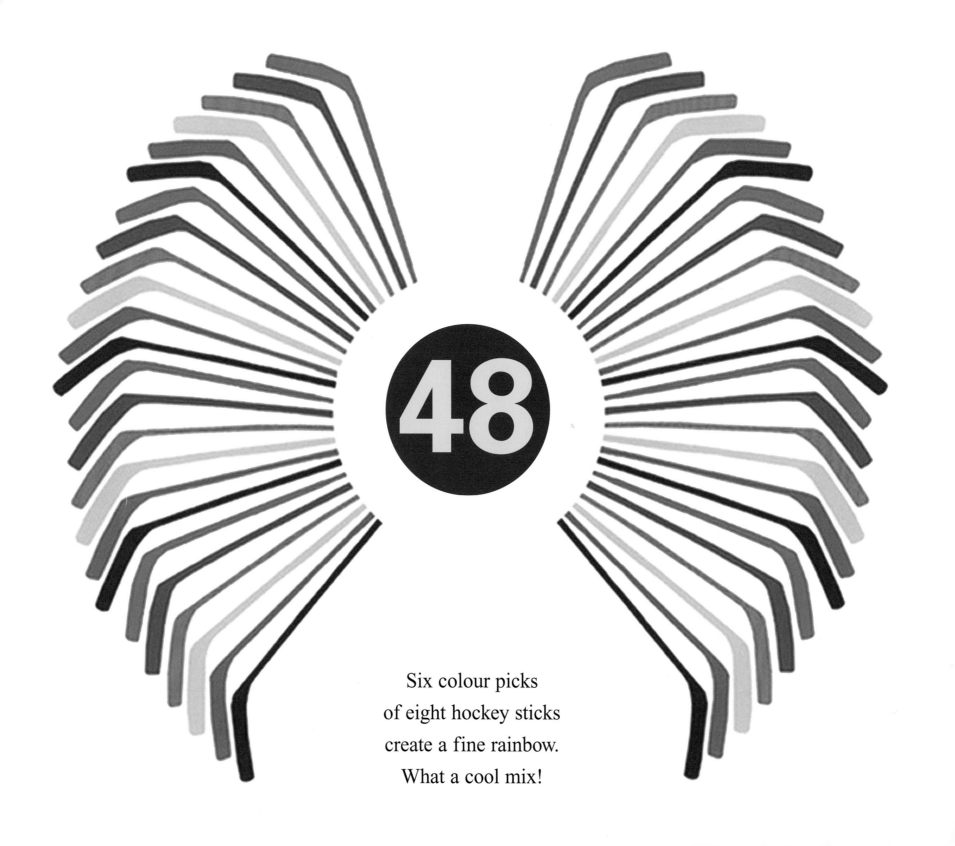

48

Six colour picks
of eight hockey sticks
create a fine rainbow.
What a cool mix!

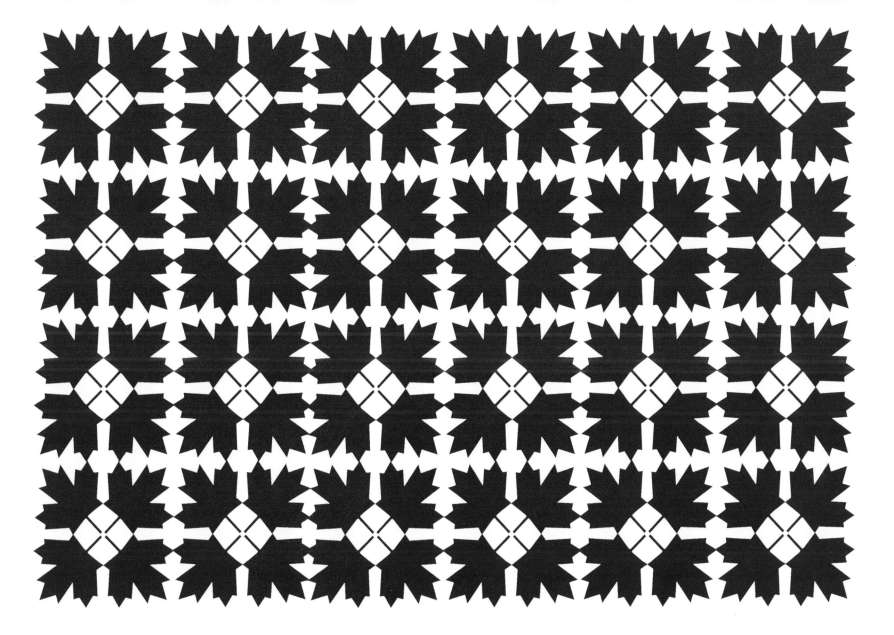

**96**

The maple leaf built into a quilt
looks pretty neat, and warms your feet.

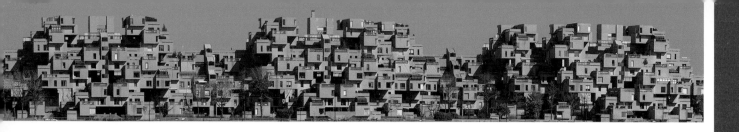

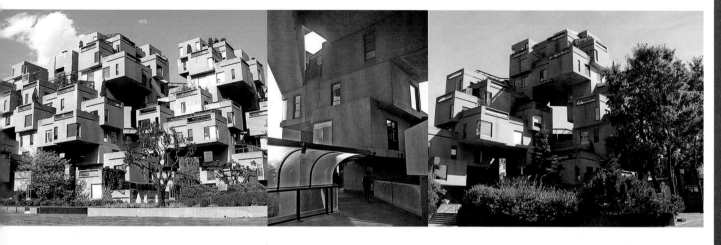

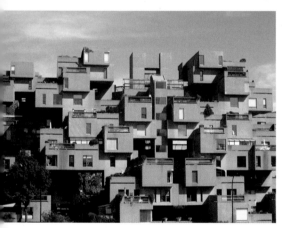

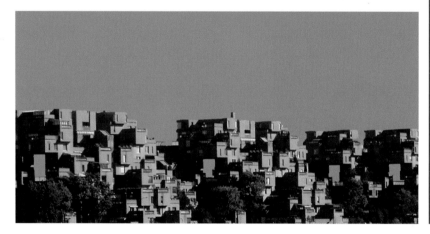

1967 was Canada's 100th birthday.

# 1982

1982 Canada's Constitution came home.

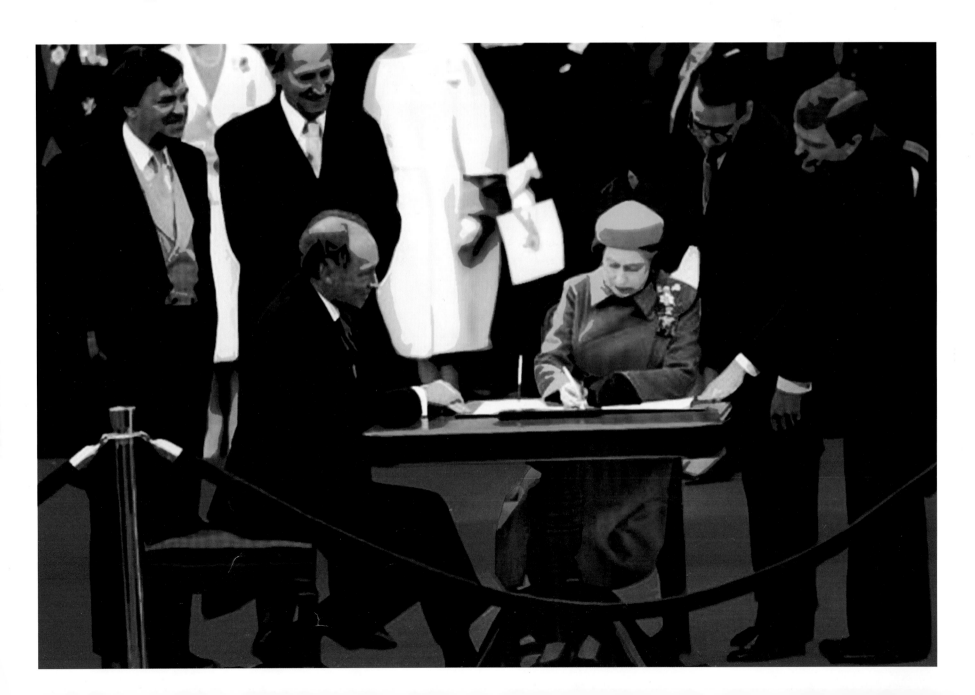

# Hundreds

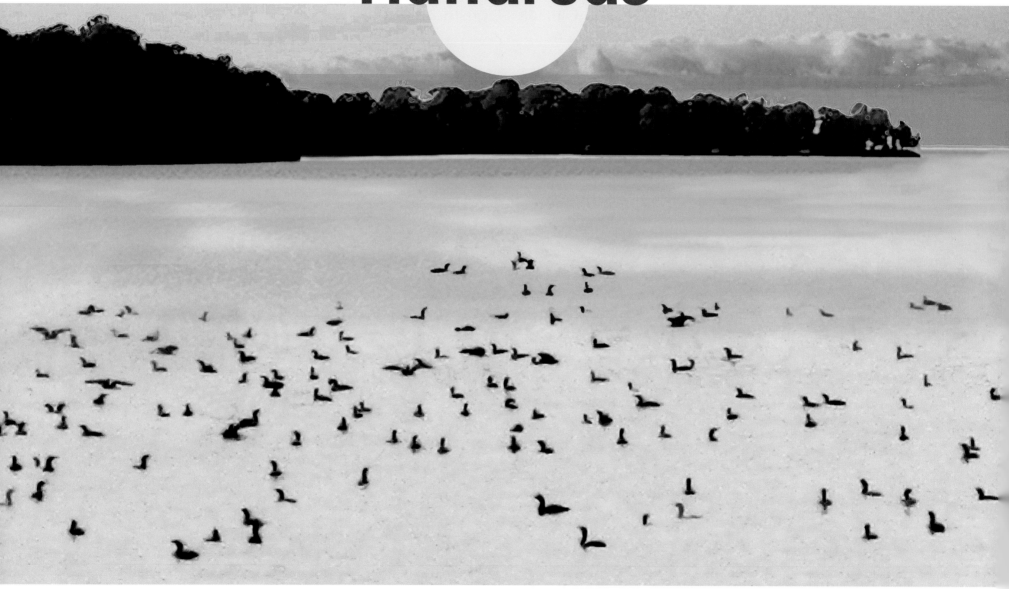

Hundreds of birds flew down from the sky,
on a quiet summer morning, and caught my eye.

# Thousands

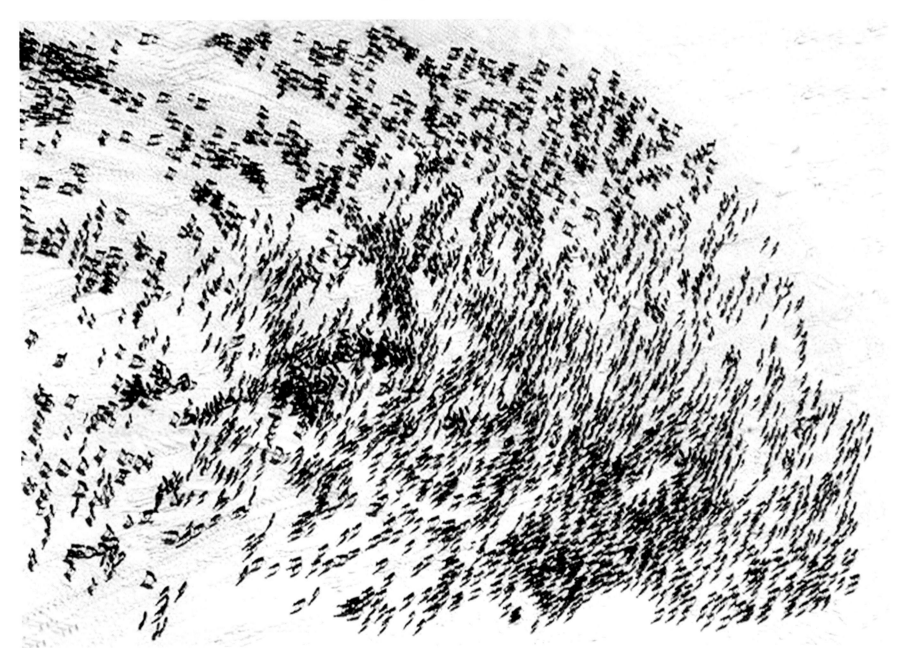

A thousand caribou seen from above.

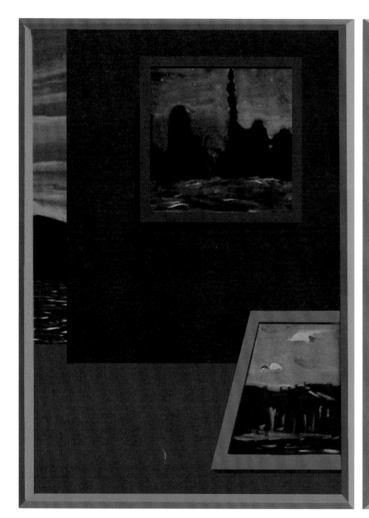

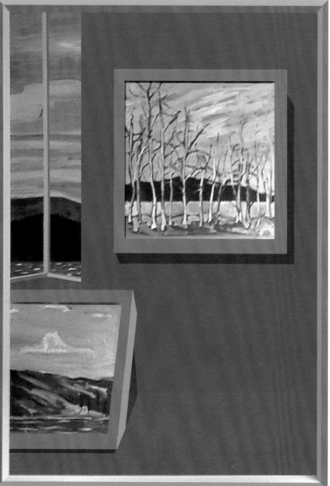

Here are my versions of the Group of Seven's art.

I painted the land and sky by heart.

Then I added two eyes, and a few other things, too.

Behold, something old became something new!

# Strawberry-Rhubarb Pie

### Filling

1¼ –1½ cups sugar

3 tablespoons cornstarch

¼ teaspoon salt

¼ teaspoon nutmeg

3 cups rhubarb,
  (cut in ¼"–½" lengths)

2 cups sliced fresh strawberries

1 tablespoon butter

### Method for filling

1. Mix sugar, cornstarch, salt, and nutmeg together.
2. Gently toss in rhubarb and strawberries and let sit on the counter for 30 minutes.
   (It's very important to give this time to thicken.)
3. Put fruit into pie crust.
4. Top with dots of butter.
5. Bake at 350° for 1 hour.

### Pastry

2 cups of pastry flour

½ teaspoon salt

½ teaspoon sugar (optional)

¾ cup butter

lemon juice

1–3 tablespoons iced water

### Method for pastry

Mix the flour, salt, and sugar in a bowl. Cut in the butter, using two knives or a pastry cutter, until the mixture resembles coarse cornmeal. Sprinkle a few drops of lemon juice over it and a very small amount of iced water — absolutely no more than 3 tablespoons — and toss lightly until it begins to come together. Form it quickly into a ball and chill before rolling it out.

Roll out quickly on a lightly floured board — making two circles, slightly larger than the pie dish. Place the first circle into the bottom of your pie dish. Cut the second circle into strips and place in alternating strips across the pie. (You may need to roll up the strip like a rug to get it off the board.) Start with an X in the middle, and lay alternating strips across the pie at the different angles. Firmly attach to the edge of the pie when trimming up the strip.

### Hints

The pie will not be as runny if you put a lattice pie crust on top as some of the moisture evaporates.

Also, after turning off the oven, leave the pie in for 15–20 minutes after baking. This also helps to prevent it from being runny.

The recipe for the filling and the tips for baking the strawberry-rhubarb pie were passed down by Ruby Cooke, to her daughter Marva Goddard.

# Nanaimo Bar Recipe

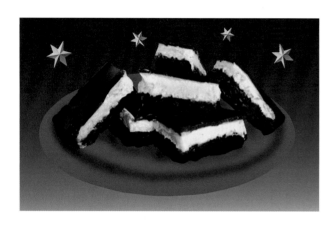

### Bottom Layer

½ cup unsalted butter (European style cultured)

¼ cup sugar

5 tablespoons cocoa

1 egg, beaten

1¼ cups graham wafer crumbs

½ cup finely chopped almonds

1 cup coconut

First melt butter in a double boiler. Add sugar and cocoa. Mix thoroughly. Add egg and stir until mixture is thick. Remove from heat. Stir in crumbs, nuts, and coconut. Press firmly into an ungreased 8" x 8" pan.

### Second Layer

½ cup unsalted butter (at room temperature)

2 tablespoons and 2 teaspoons cream (at room temperature)

2 tablespoons vanilla custard powder

2 cups icing sugar

Cream butter, cream, custard powder, and icing sugar together well. Beat until light. Spread over bottom layer.

### Third Layer

4 squares semi-sweet chocolate (1 oz. each)

2 tablespoons unsalted butter

Melt chocolate and butter in a double boiler. Cool. Once cool, but still liquid, pour over second layer and chill in refrigerator.

Cut into 16 two-inch squares, or 64 one-inch squares. Keep in refrigerator up to one week — if you can.

According to the City of Nanaimo website, the recipe for Nanaimo bars begins in the 1960s when a Nanaimo woman entered her recipe for chocolate squares in a magazine contest. In a burst of civic pride, she chose to name her recipe after her hometown, Nanaimo. The entry won a prize. Although there are many versions of the Nanaimo bar recipe, this is the official recipe from the City of Nanaimo.

Recipe for the Nanaimo bar used with the permission of the City of Nanaimo.

# About the Images

**One moose swimming and one man in one canoe**. Yes, moose do swim. This is the same sumach tree I painted for "A is for Autumn" in *M is for Moose*. This lake is my favourite place to be. It's Lake Simcoe, one of the largest lakes in Ontario, and one of the largest lakes in the world to freeze over completely in winter. I spent many memorable childhood summers here, and I now paint in a studio I converted from a former ice-storage depot right at the water's edge. Too bad there are no moose swimming in Lake Simcoe these days, but one can hope!

The lake is 30 kilometres long and 25 kilometres wide. The maximum depth is 41 metres and it contains 11.6 cubic kilometres of water.

Lake Simcoe was first called Ouentironk (Beautiful Water) by the Hurons. Later it was called Lac Toronto by the Iroquois guide Lahontan, meaning passage or gateway, as it was an important route for First Nations people, who canoed across it to get to the upper Great Lakes to trap furs, thus bypassing treacherous Niagara Falls. The French called the entire area Le Passage de Toronto and named the lake Lac aux Claies, meaning lake of trellises or fishing weirs, because of the traps made by the Huron fishers. There is a national historic site in the Narrows between Lake Simcoe and Lake Couchiching where 4,000-year-old weirs have been discovered. John Graves Simcoe renamed the lake in 1793 in memory of his father, who died en route to Québec with General Wolfe at the beginning of the French-English War in 1759, and was buried at sea off Anticosti Island in the Gulf of St. Lawrence.

**One noble caribou**. Caribou is a name for North American reindeer, from the Mi'kmaq word *qalipu*, meaning snow-shoveller.

**One woman in a sari**. I did this painting of my friend Nalini Stewart in a beautiful turquoise sari after she introduced me to the wonders of India in 2005. She has written for many Canadian publications including *Maclean's* magazine and *Toronto Life*. She has served on the boards of The Canada Council for the Arts, the Ontario Trillium Foundation, the National Theatre School of Canada, and the National Ballet School. She is a former Chair of the Ontario Arts Council.

**Two planes**. The Beaver is a single-engine, high-wing, propeller-drive bush plane developed by De Havilland Canada for carrying cargo and passengers to regional and otherwise inaccessible areas in Canada's north. Its first flight was August 16, 1947, and it was in production until 1967. There were 1,657 Beavers built. In November 1999, the Royal Canadian Mint commemorated the Beaver on a special edition of the Canadian quarter. In 2006, Viking Air of Victoria, BC, bought the designs for the Beaver.

The Otter is a later and larger version of the Beaver. Its first flight was December 12, 1951, and it was in production until 1967. There were 466 Otters built. Like the Beaver, the designs for the Otter are owned by Viking Air, which has re-launched the production of the Twin Otter with turbine engines.

**Three dog portraits**. Leslie was my first pet, a mix of collie and spaniel. I drew this portrait of him when I was twelve in 1954. I called him Leslie since that was what my immigrant grandmother called the star of the television show *Lassie*.

**Four colourful tents**. Tents are temporary shelters made of fabric, poles, ropes, and stakes or pegs. They have played an important role in the history of

Canada, from the time of the Ojibwa who built wigwams in the eastern part of the country, and teepees, built by the Lakota and Sioux on the prairies. Wigwams are often domed structures made with curved wooden poles, and covered with brush, bark, reeds, or hides. A teepee is a conical structure made of wooden poles and hides or birch bark. Unlike tents, wigwams and teepees were permanent and served to shelter families in all seasons.

In 1793, John Graves Simcoe brought a large tent — The Canvas House — from England to shelter himself and his family in the new settlement of York, later renamed Toronto. The Canvas House was originally owned by Captain James Cook.

**Five women with funny faces**. The "primitive masks" are my Picasso-inspired faces of Margaret Trudeau, Princess Diana and Mila Mulroney, Sheila Copps, and Barbara Kingstone.

**The Famous Five**. The Famous Five, also known as the Valiant Five, consisted of five women who in 1927 asked the Supreme Court of Canada if the word "Persons" in the British North America Act of 1867 included women. This seems obvious today. But the Supreme Court of 1927 did not think so; it was unanimous in its ruling that women were not persons under the law, which meant that they could not be senators. The case was then referred to the Judicial Committee of the Privy Council in England, where the Canadian Supreme Court's decision was overturned, making women persons under Canadian law.

The Famous Five were: Henrietta Muir Edwards, who was an advocate for working women and a founding member of the Victorian Order of Nurses; Nellie Mooney McClung, who was a member of the

Alberta legislature; Louise McKinney, who was the first woman elected to the Alberta legislature, any Canadian legislature, and any legislature in the British Empire; Emily Murphy, who became the first female judge in the British Empire; and Irene Parlby, who was a farm women's leader and the first woman cabinet minister in Alberta. All five women were from Alberta.

There are two identical statues of the Famous Five, by Barbara Paterson: one in the Olympic Plaza in downtown Calgary and the other on Parliament Hill in Ottawa. The City of Edmonton has named five parks in its River Valley Parks System in honour of these women.

**Six friends**. The people in this 1978 painting were visiting my farm in Oro-Medonte. They are, from left to right: Moses Znaimer, Toller Cranston, Ruby Bronsten, Marci Lipman, Lynn King, and Venable Herndon.

**Franklin Carmichael** (May 4, 1890–October 24, 1945) was the youngest original member of the Group of Seven. Born in Orillia, Ontario, Carmichael studied at the Ontario College of Art in Toronto and was an apprentice at Grip Ltd., a design firm that employed a number of important Canadian artists in the early twentieth century. He trained with other artists, including Tom Thomson, and would often go on weekend sketching trips with them. In 1913, he travelled to Belgium to study painting, but was forced to return because of the start of World War I. Famous for his watercolour paintings of northern Ontario landscapes, Carmichael founded the Ontario Society of Watercolour Painters in 1925 and the Canadian Group of Painters in 1933, and taught at the Ontario

College of Art from 1932–1945, where he was appointed head of Graphic and Commercial Art.

**Lawren S. Harris** (October 23, 1885–January 29, 1970) was known as the stimulus of the Group of Seven. Harris was born to a wealthy family in Brantford, Ontario, studied in Berlin when he was nineteen, and in 1911 founded the Group of Seven with J.E.H. Macdonald. In 1913, he helped finance construction of the Studio Building in Toronto, providing cheap homes and workspace for artists. Harris organized painting trips for the Group to Algoma and the north shore of North Superior, made several trips to the Rockies, and spent time in New Hampshire and New Mexico before eventually settling in Vancouver. Able to support himself his entire life through painting, Harris is best known for the stark, abstract quality of his northern and Arctic landscapes. He was made a Companion of the Order of Canada in 1969.

**A. Y. Jackson** (October 3, 1882–April 5, 1974) was born in Montréal. He was first exposed to art as a young boy, working for a lithograph company and taking evening classes at Le Monument National. He travelled to the US, France, Italy, and the Netherlands, before settling in Sweetsburg, Québec. When his painting *The Edge of Maple Wood* appeared in a Toronto art show, it led to correspondences and visits with J. E.H. Macdonald and Lawren Harris. He often accompanied them on their painting trips, where they developed a bold style of landscape painting. In 1914, he enlisted with the Canadian Army, but was wounded shortly after reaching the front in 1916. He later went on to work for Canadian War Records, Canadian War Memorials, taught at the Ontario College of Art, and helped found the Canadian Group of Painters.

**Frank Johnston** (June 19, 1888–July 19, 1949) was born in Toronto. He worked at Grip Ltd. He participated in the Algoma painting trips, exploring the landscape with tempera paints. Although he was a founding member of the Group, he exhibited with them only once before eventually resigning his position in 1924. Turning away from the style of his peers, Johnston's work grew more realistic and decorative. He worked for department-store art galleries for a time, taught at the Ontario College of Art during the 1920s, and held many successful solo exhibitions.

**Arthur Lismer** (June 27, 1885–March 23, 1969) was born in Sheffield, England. Apprenticed to a photo-engraver at the age of thirteen, Lismer moved to Antwerp, Belgium, in 1905, to study at the Académie Royale. He settled in Toronto in 1911 and took a job with Grip Ltd. Inspired by post-impressionism, Lismer's paintings feature vivid colour and coarse brushwork. He was on the Pictures Committee for the Centennial of the City of Toronto in 1934, and was made a Companion of the Order of Canada in 1967.

**J.E.H. Macdonald** (May 12, 1873–November 26, 1932) was born in Durham, England, but moved to Hamilton in 1887, and then Toronto in 1889. While exhibiting sketches at the Arts and Letters Club in 1911, Macdonald became acquainted with Lawren Harris. Together, they began to gather Canadian artists interested in developing a new national style. While his earliest work, in the post-impressionist style, was reviled by critics, Macdonald's later mountain landscapes paintings — inspired by trips to Algoma — were celebrated. In 1928, Macdonald became Principal of the Ontario College of Art.

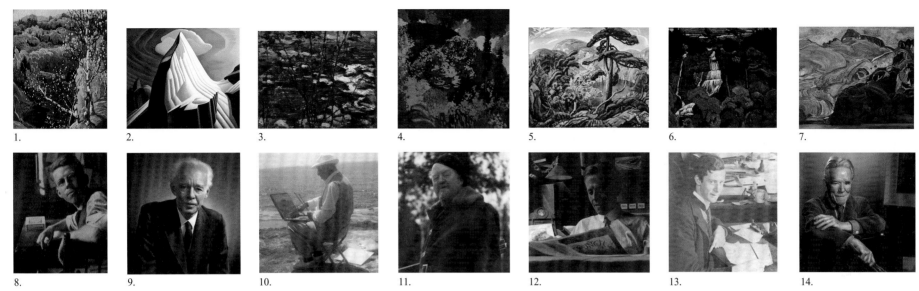

1.

2.

3.

4.

5.

6.

7.

8.

9.

10.

11.

12.

13.

14.

**Frederick Varley** (January 2, 1881–September 8, 1969), known as the gypsy of the Group of Seven for his romantic and independent spirit, was also born in Sheffield, England, and studied art there and in Belgium. On the advice of Arthur Lismer, another native of Sheffield, Varley travelled to Canada to work for Grip Ltd. Though a founding member of the Group, he preferred to paint portraits until later in his career. His combat pieces, based on his time served during World War I, inspired others in the Group of Seven to portray scenes of harsh conditions and climates.

**Eight square dancers**. Square dancing is a North American folk dance in which four couples (eight dancers) form a square and dance to steps described by a square-dance caller to the beat of fiddle music. Square dancing is believed to have originated in seventeeth-century England, France, and Scotland.

**Nine portraits**. The people in these portraits are (clockwise from the upper left image): Moses Znaimer and Marilyn Lightstone; Sir Wilfrid Laurier; Sara Pachter, also known as "Dibbles"; Sharon Stewart; Arthur Gelber; Marie-France Maury; and Robert and Bogomila Welsh.

**Nine judges supreme**. When I painted this in January 2009, the justices on the Supreme Court were: back row, left to right: The Honourable Madam Justice Louise Charron; the Honourable Mr. Justice Morris J. Fish; the Honourable Madam Justice Rosalie Silberman Abella; and the Honourable Mr. Justice Marshall Rothstein. Front row, left to right: The Honourable Mr. Justice Louis LeBel; the Honourable Mr. Justice Michel Bastarache; the Right Honourable Beverley McLachlin, P.C., Chief Justice of Canada; the Honourable Mr. Justice William Ian Corneil Binnie; and the Honourable Madam Justice Marie Deschamps.

The Supreme Court of Canada is located in Ottawa and is the final court of appeal in the country for individuals and governments. Its jurisdiction includes the civil law of Québec and the common law of the other provinces and territories. The Court was created by an Act of Parliament in 1875, but did not sit until January 17, 1876. It is composed of one Chief Justice and eight puisne judges. *Puisne* is an old French word meaning younger. As was mentioned under the Famous Five, decisions made by Canada's Supreme Court could be appealed to the Judicial Committee of the Privy Council in England. This right of appeal was abolished in two stages: first, for criminal cases, in 1933, and then for all other cases in 1949. The art-deco building that houses the Court was designed by the Montréal architect Ernest Cormier, who also designed the Université de Montréal and the French Embassy in Ottawa.

**Eleven loons** on Lake Simcoe swimming in front of my studio.

The loon has beautiful markings and patterns, but is best known for its haunting call. It is a water bird, like the duck, and consists of five species: the Red-throated Loon *Gavia stellata*, the Pacific Loon *Gavia pacifica*, the Arctic Loon *Gavia arctica*, the Yellow-billed Loon *Gavia adamsii*, and the Common Loon *Gavia immer*. The Common Loon is the species best known to Canadians, as most of Canada is its natural breeding ground. Like the other four species of loon, the Common Loon migrates in winter to the east, west, and south coasts of North America.

**Leif Eriksson** (970–1020) is thought to be the first European to set foot in North America, 500 years before Christopher Columbus. Son of infamous Norse sailor and outlaw Erik the Red, Eriksson was a Christian convert from Greenland. When he heard Bjarni Herjólfsson's tale of a land to the west, he bought Herjólfsson's boat and set sail to find it. His journey took him first to Baffin Island and then Labrador, before he finally landed in Newfoundland and established a colony there called Vinland. Its ruins are located at L'Anse aux Meadows, a world heritage site.

**John Cabot** (1450–1498), born Giovanni Caboto, was a Venetian navigator and the second European to "discover" the North American mainland. He was commissioned by King Henry VII to seek and claim new lands for England. In 1497, Cabot reached the New World; although the exact location of this spot is unknown, Cape Bonavista in Newfoundland is celebrated as his official point of landing. Upon his return to England, Cabot was made an admiral and outfitted with a new fleet. He set sail in 1498 and was never heard from again.

**Jacques Cartier** (December 31, 1491–September 1, 1557) was a French explorer who claimed the land now called Canada in the name of France. Commissioned by King Francis I to seek a westward passage to the Orient, Cartier set sail in 1534. He explored Newfoundland, parts of the Maritime provinces, and the Gulf of St. Lawrence, and encountered Mi'kmaq and Iroquois First Nations before returning to France. On his second and third voyages, Cartier sailed farther up the St. Lawrence and spent more time in the land he called "the country of Canadas" after two important Iroquois settlements.

**Samuel de Champlain** (1580–December 25, 1635) was a French explorer known as the Father of New France. He first visited North America with fur traders and, inspired by Jacques Cartier, created a map of the St. Lawrence as well as wrote an account of his travels. In 1608, de Champlain was commissioned to establish the first permanent colony in North America, at what is now Québec City. In addition to administering Québec, he explored the Ottawa River, Lake Ontario, and Lake Huron, and established relations with several First Nations tribes.

**Robert de la Salle** (November 22, 1643–March 19, 1687) was a French explorer who settled in New France, where the Iroquois told him of a great river to the west. Hoping to discover a passage to the Pacific, de la Salle instead was led south to the Mississippi Basin. Undaunted, de la Salle claimed the land for France. He later founded Fort Cataraqui, now Kingston, Ontario, explored the Great Lakes, and made further expeditions into the southern US. de la Salle was killed by mutineers in what is now Texas.

**Pierre de Charlevoix** (October 29, 1682–February 1, 1761) was a French Jesuit and the first historian of New France. Sent by the Society of Jesus, de Charlevoix travelled from the Great Lakes to the Mississippi basin, making detailed scientific observations along the way. He wrote several histories, the most important of which documents the history of the French regime in the New World.

**James Cook** (November 7, 1728–February 14, 1779) was a captain of the British Royal Navy. On assignment, he became the first person to map Newfoundland. Cook believed that would be the limit of his exploration, but in 1766, he was hired by the Royal Society to travel to Tahiti. This was the first of three incredible voyages throughout the Pacific, in which Cook would visit the lands and peoples of Australia, New Zealand, Hawaii, as well as the western coast of North America, from California to the Bering Strait. Captain Cook was so celebrated that his ships were considered off-limits during the American Revolution. He was killed in 1779 in a dispute with native Hawaiians.

**George Vancouver** (June 22, 1757–May 10, 1798) was a captain in the Royal Navy famous for exploring the northwest coast of North America. Born in England, Vancouver served under Captain James Cook on his voyages around the world. He was eventually commissioned to explore the coastlines of northwest North America, where he mapped the coasts of Washington, Oregon, and British Columbia all the way to Alaska, and was the first European to enter what is now the main harbour of the city of Vancouver.

**Alexander Mackenzie** (1764–March 12, 1820) was born in Scotland but moved to Montréal as a boy. He found work with the North West Company as an explorer, and is most famous for discovering the Mackenzie River, the longest river in Canada, and for navigating it all the way to the Arctic Ocean. Hoping that the Mackenzie would instead lead to the Pacific, he originally named it Disappointment River. He was knighted in 1802 and served in the Legislature of Lower Canada from 1804–1808.

**David Thompson** (April 30, 1770–February 10, 1857) was called by some of his peers "the greatest land-geographer to have ever lived." Born in Wales, Thompson was apprenticed to the Hudson's Bay Company and sent to Churchill, Manitoba, where he learned the art of surveying. He then defected to the North West Company and went on to survey huge tracts of land including all the area from Lake Superior to the Fraser River. In total, Thompson mapped over 3.9 million square kilometres of North America.

**Simon Fraser** (May 20, 1776–August 18, 1862) was a fur trader best known for charting much of British Columbia. Born in Mapletown, New York, Fraser's family moved to Québec during the American Revolutionary War. He became a fur trader and, by 1805, was responsible for the North West Company's operations west of the Rockies. He established a number of forts and trading posts and navigated numerous bodies of water, including the river and lake that now bear his name.

**John Franklin** (April 16, 1786–June 11, 1847) was an officer of the Royal Navy, best known for his explorations of the Arctic coasts of Canada. His first expedition was ill-supplied; many men starved, and Franklin was forced to eat his own boots. Later, after briefly serving as Lieutenant-Governor of Van Diemen's Land (Tasmania), Franklin was sent to search for a sailing passage from Europe to the Pacific. He disappeared while attempting to chart and navigate a section of the Northwest Passage in the Canadian Arctic. The expedition's icebound ships were abandoned in desperation, and the entire crew perished.

**British Columbia** joined Confederation on July 20, 1871, making it the sixth province. It is our westernmost province. It ranks fifth in area, with 944,735 square kilometres and it ranks third in population, with more than 4,400,000 people. The capital of BC is Victoria. Its provincial flower is the Pacific Dogwood; its tree is the Western Red Cedar; and its bird is the Steller's Jay. People have lived in BC for about 11,500 years and in the late 1700s, when James Cook mapped the coast, there were at least ten nations of indigenous people; these were the nations of the Tlingit, the Nisga'a, the Haida, the Tsishian, the Haisla, the Heiltsuk, the Wuikinuxv, the Kwakwaka'wakw, the Nuu-chah-nulth, and the Coast Salish, which included the Nuxálk. After James Cook, George Vancouver, Alexander Mackenzie, John Finlay, Simon Fraser, Samuel Black, and David Thompson were noted European explorers of the region.

**Alberta** joined Confederation on September 1, 1905, making it the ninth province. It ranks sixth in area, with 661,848 square kilometres and it ranks fourth in population, with more than 3,630,000 people. The capital of Alberta is Edmonton. Its provincial flower is the Wild Rose; its tree is the Lodgepole Pine; and its

bird is the Great Horned Owl. Before it was a province, Alberta was a district of the Northwest Territories. Today, the are many First Nations people in Alberta; they include the Ermineskine Cree Nation, the Blood Tribe, the Buffalo Lake Metis Dene Tha' First Nation, the Horse Lake First Nation, the Kapawe'no First Nation, the Litter Red River Cree Nation, the Mikisew Cree First Nation, the Piikani Nation, the Siksika Nation, the Stoney Nation, the Tsuu T'ina Nation, and the West Moberly First Nation.

**Saskatchewan** joined Confederation on September 1, 1905, making it the eighth province. It ranks seventh in area, with 651,900 square kilometres and it ranks sixth in population, with just over 1,022,000 people. The capital of Saskatchewan is Regina. Its provincial flower is the Western Red Lily; its tree is the Paper Birch; and its bird is the Sharp-tailed Grouse. Prior to the arrival of the Europeans, the area now known as Saskatchewan was populated by the Athabaskan, Algonquian, Atsina, Cree, Saulteaux, and Sioux tribes. The first European settlement was founded by Samuel Hearn in 1774; it was named Cumberland House and was a Hudson's Bay Company post.

**Manitoba** joined Confederation on July 15, 1870, making it the fifth province. It ranks eighth in area, with 649,950 square kilometres and fifth in population, with just over 1,200,000 people. The capital of Manitoba is Winnipeg. Its provincial flower is the Prairie Crocus; its tree is the White Spruce; and its bird is the Great Grey Owl. The name Manitoba is possibly derived from an indigenous language: Cree, Ojibwa, or Assiniboine. Other tribes that lived in the geographical area included the Dene, the Sioux, and the Mandan.

**Ontario** was one of the four original provinces of Confederation, July 1, 1867. It covers the fourth largest area, with 1,076,395 square kilometres and it has the largest population, with almost 13,000,000 people. The capital of Ontario is Toronto. Its provincial flower is the White Trillium; its tree is the Eastern White Pine; and its bird is the Common Loon. The name Ontario is an altered form of a Huron word or an Iroquoian word, one meaning beautiful water and the other great lake. Before the arrival of the Europeans, the area was populated by the Ojibwa, Cree, and Algonquin tribes in the west and by the Iroquois and Huron in the east. The French explorer Étienne Brûlé is believed to have explored the area as early as 1610. In 1611, Henry Hudson claimed the territory south of what was to become Hudson's Bay for England. In 1615 Samuel de Champlain reached Lake Huron.

**Québec** was one of the original provinces of Confederation. It covers the second largest area, with 1,542,056 square kilometres and it has the second largest population, with almost 7,800,000 people. The capital of Québec is Québec City. Its provincial flower is the Blue Flag Iris; its tree is the Yellow Bird; its bird is the Snowy Owl. The name Québec comes from the Algonquin word *kébec*, meaning where the river narrows. When the Europeans first arrived, the Algonquin, Iroquoian, and Inuit populated the area, along with the Cree in what is now James Bay, the Innu, and in the south and east of the province, the Mi'kmaq and the Abenaki. Early Europeans to arrive in Québec included the French explorers Jacques Cartier and Samuel de Champlain, as well as Basque whalers.

**New Brunswick** was one of the original provinces of Confederation. It covers the eleventh largest area, with 72,908 square kilometres and it has the eighth largest population, with almost 750,000 people. The capital of New Brunswick is Fredericton. Its provincial flower is the Purple Violet; its tree is the Balsam Fir; and its bird is the Black-Capped Chickadee. The province's name comes from the English translation of the name of the German ancestral home of George III of the United Kingdom, Braunschweig. The most populous tribe in what is now New Brunswick were the Mi'kmaq and the Wolastoqiyik (Maliseet), who lived in the western part of the province. The first known European explorer to reach New Brunswick was Jacques Cartier.

**Nova Scotia** was one of the original provinces of Confederation. It covers the twelfth largest area, with just over 22,250 square kilometres and it has the seventh largest population, with almost 950,000 people. The capital of Nova Scotia is Halifax. Its provincial flower is the Mayflower; its tree is the Red Spruce; and its bird is the Osprey. The name Nova Scotia means New Scotland. Over 10,000 years ago, the Paleo-Indians, believed to be a nomadic people, lived in what is now Nova Scotia. When John Cabot, the first European explorer, arrived in Cape Breton in 1497, the Mi'kmaq were the people inhabiting the land. The first European settlement, Port Royal, was established more than a century later, in 1604. Although destroyed in 1613 by the British, Port Royal has been reconstructed and is now a major heritage site. Nova Scotia is one of two provinces to have a dog named for it: the Nova Scotia Duck Tolling Retriever.

**Prince Edward Island** joined Confederation on July 1, 1873, making it the seventh province to do so. It is the smallest of the provinces and territories, with an area of 5,683 square kilometres. It has the smallest population of the provinces (only the territories are smaller); there are about 141,000 people living on the island. Its provincial flower is the Pink Lady's Slipper; its tree is the Red Oak; and its bird is the Blue Jay. Its capital is Charlottetown, named for Queen Charlotte, the wife of King George III. Originally inhabited by the Mi'kmaq people, who named the island Epekwitk, meaning land cradled on the waves, it was first visited by Jacques Cartier in 1534. The province is considered the birthplace of Confederation, as the first conference that lead to Confederation took place in Charlottetown in 1864.

**Newfoundland and Labrador** joined Confederation on March 31, 1949, making it the tenth province. It covers the tenth largest area, with 405,212 square kilometres and it has the ninth largest population, with almost 509,000 people. Its provincial flower is the Pitcher plant; its tree is the Black Spruce; its bird is the Atlantic Puffin. Its capital is St. John's. Human habitation in Newfoundland has been traced back 9,000 years to the people of the Maritime Archaic Tradition. Subsequent inhabitants were the Palaeoeskimo people of the Dorset Culture, and in Labrador the Innu and Inuit, and the Beothuks on the island of Newfoundland. The oldest European contact was made well over 1,000 years ago when the Vikings settled in L'Anse aux Meadows. Five hundred years later, European explorers and fisherman from England, Ireland, Portugal, France, and Spain fished off its coasts, as well as Basque whalers. Newfoundland is one of two Canadian provinces to have a dog named for it: the Newfoundland and the Labrador Retriever.

**Yukon Territory** joined Confederation on June 13, 1898, making it the ninth political jurisdiction. It covers the ninth largest area, with 482,443 square kilometres and its population is twelfth, with just under 33,500 people. Its territorial flower is the Fireweed; its tree is the Subalpine Fir; and its bird is the Common Raven. Its capital is Whitehorse. On the top of its coat of arms is an Alaskan Malamut, standing on a mound of snow. There are a number of First Nations in the Yukon, including the Carcross/Tagish First Nation, the Champagne and Aishihik First Nations, the First Nation of Nacho Nyak Dun, the Kluane First Nation, the Laird River First Nation, the Little Salmon/Carmacks First Nation, and the Ross River Dene Council. The Klondike Gold Rush of 1897 brought thousands of people to what was then the Yukon District of the Northwest Territories. The separate Yukon Territory was established in the following year.

**Northwest Territories** joined Confederation on July 15, 1870, making it the fifth political jurisdiction, when the Hudson's Bay Company ceded the territory to Canada. It covers the third largest area, with 1,346,106 square kilometres and its population is ranked eleventh, with approximately 42,000 people. Its territorial flower is the Mountain Avens; its tree is the Tamarack Larch; and its bird is the Gyrfalcon. Its capital is Yellowknife. What is now the Northwest Territories was created when Rupert's Land and the North-Western Territory were transferred to Canada; at the time, this territory included what are now the provinces of Alberta, Saskatchewan, Manitoba, and the Yukon and Nunavut territories. Parts of what are now British Columbia, Ontario, and Québec were also part of the Northwest Territories. The Official Languages Act of the Northwest Territories recognizes eleven official languages, which is the most of any political jurisdiction in Canada. The languages are: Chipewyan, Cree, English, French, Gwich'in, Inuinnaqtun, Inuktitut, North Slavey, South Slavey, and Ttjch.

**Nunavut** joined Confederation on April 1, 1999, making it the thirteenth political jurisdiction. Prior to this date, it was part of the Northwest Territories. It covers the largest geographical area, with 2,093,190 square kilometres and its population is the smallest, with just over 31,500 people. Its territorial flower is the Purple Saxifrage; it does not have a territorial tree; and its bird is the Rock Ptarmigan. Its capital is Iqaluit. For thousands of years before European contact, the Palaeoeskimo, Pre-Dorset, Dorset Culture, Thule, and Eskimo people lived here. The written history of Nunavut begins with the explorer Martin Frobisher, who, like many explorers after him, was in search of the Northwest Passage, a shorter trade route from Europe to China and India. Nunavut became its own territory as the result of a process that began in 1976 with the land claims of the Inuit Tapiriit Kanatami. In April 1982, a referendum was held throughout the Northwest Territories and a majority voted in favour of a separate Nunavut. The land claims were settled in September 1992 and in 1999 the Nunavut Land Claims Agreement Act and the Nunavut Act were passed by Parliament.

**Fifteen purple martins**. The Latin name for the purple martin is *Progne subis*; it is the largest of the

North American swallows. Eastern North America and the west coasts from Mexico to British Columbia are the breeding grounds of the purple martin. In the winter, it migrates to the Amazon basin. These purple martins lived in my birdhouse on the shoreline in front of my studio on Lake Simcoe.

**Fifteen finches**. The Latin name for the chaffinch (its proper name) is *Fringilla coelebs*. These frisky finches with bright yellow wings flitted around the feeder all summer in front of my studio on Lake Simcoe.

**Seventeen freshly husked cobs of corn**. Corn is the most common crop in North and South America. It was introduced to the Europeans by the First Nations people of the Americas. Corn's proper name is maize, which comes from the Spanish version of the Taino word *maíz*.

**Thirty-seven fathers of Confederation**. July 1, Canada Day, celebrates the joining together of the provinces of Canada (which at the time consisted of Upper and Lower Canada, Ontario and Québec, respectively) with Nova Scotia and New Brunswick in 1867. Prior to July 1, 1867, there were three conferences held where discussions lead to Confederation of the four British colonies: Charlottetown, September 1–9, in 1864; Québec, October 10–27, in 1864; and London, December 1866–March 1867. On March 29, Queen Victoria gave royal assent to Confederation, which was called the British North America Act and was passed by the legislatures of Upper and Lower Canada, Nova Scotia, New Brunswick, and the British House of Lords and House of Commons.

There are differing opinions on who should be considered the Fathers of Confederation. Generally, the term refers to the people who attended two or more of the three conferences held at Charlottetown, Québec, and London to discuss the union of the British North American colonies. Their names are listed below. Although there are thirty-seven men in the illustration, only thirty-six attended two or more conferences, representing the following provinces:

Newfoundland: Sir F. B. T. Carter, Sir Ambrose Shea.
Prince Edward Island: George Coles, John Hamilton Gray, Thomas Heath Haviland, Andrew Archibald Macdonald, Edward Palmer, William Henry Pope, Edward Whelan.
Nova Scotia: Sir Adams George Archibald, Robert Barry Dickey, William Alexander Henry, Jonathan McCully, John William Ritchie, Sir Charles Tupper.
New Brunswick: Edward Barron Chandler, Charles Fisher, John Hamilton Gray, John Mercer Johnson, Peter Mitchell, William Henry Steeves, Sir Samuel Leonard Tilley, Robert Duncan.
Québec: Sir George-Étienne Cartier, Jean-Charles Chapais, Sir Alexander Tilloch Galt, Sir Hector-Louis Langevin, Thomas D'Arcy McGee, Sir Étienne-Paschal Taché.
Ontario: George Brown, Sir Alexander Campbell, James Cockburn, William Pierce Howland, Sir John A. Macdonald, Sir Oliver Mowat.
Manitoba: William McDougall.

This image is based on Rex Woods's famous canvas painted in 1967, which was commissioned by the Confederation Life Insurance Company, and was itself based on a charcoal sketch made by Robert Harris in 1883. There was no occasion upon which all thirty-six men attended a single conference.

**1967** was Canada's Centennial year, 100 years since Confederation. The image is of Habitat 67, the landmark housing complex designed by Moshe Safdie and built on the Marc Drouin Quay on the St. Lawrence River as part of Expo 67, the World's Fair held in Montréal. The project began as Safdie's master's thesis in architecture at McGill University. It was originally designed to create affordable housing; but, because of its innovative architecture, it has become a highly desirable upscale residential address in Montréal.

**1982**. On April 17, 1982, the Canadian Constitution came home. Previously it was housed in London. It received Royal Assent on Parliament Hill when Queen Elizabeth signed it at a "homecoming" ceremony with Prime Minister Pierre Elliott Trudeau. The constitution is the supreme law of the country, and it is the result of over one hundred years of legislative work.

# More About the Art

One moose, one man, one canoe
MOOSEMANOE
Acrylic on canvas, 2009
40 x 30 in / 100 x 75 cm

One caribou
POISE
Acrylic on canvas, 2009
30 x 48 in / 75 x 120 cm

One man walking
GAIT
Acrylic on canvas, 1986
48 x 72 in / 120 x 180 cm

One woman in a sari
ODE
Acrylic and inkjet on canvas, 2006
30 x 48 in / 75 x 120 cm
Private collection, Toronto

Two friends
ARI AIR VIEW
Acrylic on canvas, 1984
72 x 36 in / 180 x 90 cm
Collection: Dr. Sheldon Jafine, Toronto

Two airplanes
OTTER
Inkjet on archival matte paper, 2009
24 x 16 in / 60 x 40 cm

BEAVER
Inkjet on archival matte paper, 2009
24 x 18 in / 60 x 45 cm

Three portraits of Ruth
3 PORTRAITS OF RUTH
Acrylic and pencil on canvas, 1980
54 x 36 in / 135 x 90 cm
Green: Private collection, Berlin

Three dogs (clockwise)
PORTRAIT OF LESLIE
Oil crayon on paper, 1954
12 x 14 in / 30 x 35 cm

PORTRAIT OF CHEYENNE
Acrylic and pencil on canvas, 1995
30 x 44 in / 75 x 110 cm
Private collection, Miami

PORTRAIT OF ELVIS
Acrylic and pastel on canvas, 1987
28 x 30 in / 70 x 75 cm
Collection: Murray Ball, Toronto

Four tents (clockwise)
NIGHT:THE CANVAS HOUSE
Acrylic and pencil on canvas, 1984
40 x 44 in / 100 x 110 cm

DISCOVERY: THE CANVAS HOUSE
Acrylic on canvas, 1988
78 x 48 in / 195 x 120 cm
Collection: Bain, Toronto

FROM THE TENT
Acrylic on canvas, 1998
40 x 30 in / 100 x 75 cm
Private collection, Toronto

TO ALL IN TENTS
Acrylic on canvas, 1987
72 x 36 in / 180 x 90 cm

Four leaves
FOUR SEASONS
Inkjet on archival matte paper, 2009
24 x 18 in / 60 x 45 cm

Five women (clockwise)
DEMOISELLE READING
Acrylic on canvas, 1988
40 x 30 in / 100 x 75 cm

DIANA & MILA
Acrylic on canvas, 1988
48 x 36 in / 120 x 90 cm

PORTRAIT OF A LADY
Acrylic on canvas, 1988
40 x 30 in / 100 x 75 cm

UNE DEMOISELLE DE TORONTO
Acrylic on canvas, 1989
48 x 60 in / 120 x 150 cm

Five famous persons
THE FAMOUS FIVE
Inkjet on archival matte paper, 2009
24 x 24 in / 60 x 60 cm

Six Nanaimo bars
BARS & STARS
Inkjet on archival matte paper, 2009
18 x 12 in / 45 x 30 cm

Six friends
SIX FIGURES IN A LANDSCAPE
Acrylic on canvas, 1978
84 x 54 in / 210 x 135 cm
Collection: Marilyn Lightstone and
Moses Znaimer, Toronto

Eight barns (clockwise)
ORO BARN 1
Inkjet on archival matte paper, 2005
18 x 12 in / 45 x 30 cm

ORO BARN WITH SILO
Acrylic on canvas, 2007
40 x 30 in / 100 x 75 cm

ORO BARN 2
Inkjet on archival matte paper, 2005
18 x 12 in / 45 x 30 cm

ORO BARN 4
Inkjet on archival matte paper, 2005
18 x 12 in / 45 x 30 cm

THREE RED BARNS
Acrylic on canvas, 2004
40 x 30 in / 100 x 75 cm

ORO BARN 3
Inkjet on archival matte paper, 2005
18 x 12 in / 45 x 30 cm

Eight square dancers
ROUND SQUARE
Acrylic on canvas, 1978
30 in / 75 cm diameter

Nine portraits (clockwise)
SIR WILFRID LAURIER
Acrylic on canvas, 1988
44 x 42 in / 110 x 105 cm
Collection: Canadiana Fund, Ottawa

SARA PACHTER
Acrylic and coloured pencil on
canvas, 2008
24 x 36 in / 60 x 90 cm

SHARON STEWART
Acrylic and coloured pencil on
canvas, 1978
30 x 40 in / 75 x 100 cm
Collection: Sharon Stewart, Toronto

ARTHUR GELBER
Acrylic and coloured pencil on
canvas, 1978
40 x 30 in / 100 x 75 cm
Collection: Ontario Arts Council,
Toronto

MARIE-FRANCE MAURY
Acrylic and pencil on canvas, 1996
30 x 44 in / 75 x 110 cm
Private collection, Toronto

MARILYN LIGHTSTONE &
MOSES ZNAIMER
Acrylic and coloured pencil on two
canvases, 1989
104 x 52 in / 260 x 130 cm
Collection: Marilyn Lightstone &
Moses Znaimer, Toronto

(centre )
ROBERT & BOGOMILA WELSH
Acrylic and coloured pencil on canvas,
  1989
84 x 42 in / 210 x 105 cm
Collection: Bogomila Welsh-Ovcharov,
  Toronto

Nine judges
  THE SUPREMES
  Acrylic and pencil on canvas, 2008
  48 x 36 in / 120 x 90 cm

Ten flags
  THE PAINTED FLAGS
  10 paintings
  Acrylic on canvas, 2003
  30 x 24 in / 75 x 60 cm

Eleven loons
  LOONS
  3 images
  Inkjet on archival matte paper, 2007
  18 x 10 in / 45 x 25 cm
  16 x 12 in / 40 x 30 cm
  18 x 10 in / 45 x 25 cm

Twelve explorers
  FAMOUS EXPLORERS
  Inkjet on archival matte paper, 2009
  20 x 20 in / 50 x 50 cm

Thirteen maps and flags
  COUNTRY WIDE
  Inkjet on archival matte paper, 2009
  40 x 16 in / 100 x 40 cm

Fourteen chairs
  FRONT ROW SEATS AT THE SKY
    CIRCUS
  7 images
  Inkjet on archival matte paper, 2009

Fifteen purple martins
  BIRD VILLA
  Acrylic on canvas, 2004
  30 x 36 in / 75 x 90 cm

Fifteen finches
  FEEDING AT THE FEEDER
  Acrylic on canvas, 2006
  30 x 40 in / 75 x 100 cm

Sixteen dancers
  EIGHT COUPLES DANCING
  Acrylic on canvas, 2002
  48 x 36 in / 120 x 90 cm

Seventeen cobs of corn
  GOLDEN EARS
  Inkjet on archival matte paper, 2007
  20 x 16 in / 50 x 40 cm

Eighteen fruit and vegetables
  RED PEPPERS
  Acrylic on canvas, 1995
  40 x 30 in / 100 x 75 cm

  GRAPEFRUIT
  Acrylic on canvas, 1995
  30 x 40 in / 75 x 100 cm

  APPLES
  Acrylic and coloured pencil on canvas,
    1995
  60 x 48 in / 150 x 120 cm
  Collection: Leeanne Weld and Chris
    Kostopoulos, Toronto

Nineteen hands
  HANDS
  6 paintings
  Acrylic on canvas, 1985–90

Twenty hay bales
  OF THE FIELDS
  Acrylic on canvas, 2003
  48 x 36 in / 120 x 90 cm

Twenty-four maple leaves
  BY DESIGN
  Inkjet on canvas, 2009
  40 x 32 in / 100 x 80 cm

Three-letter word
  EH ARE TEE
  3 panels
  Acrylic on canvas, 2007
  24 x 24 in / 60 x 60 cm

Twenty-six hand signs
  HAND DANCE
  Inkjet on canvas, 2009
  24 x 30 in / 60 x 75 cm

Twenty-nine caribou
  TREK
  Acrylic on canvas, 2008
  50 x 24 in / 125 x 60 cm

Thirty-seven fathers of Confederation
  THE NATIONAL
  Acrylic on canvas, 2003
  48 x 24 in / 120 x 60 cm

Forty-eight hockey sticks
  SPECTRUM
  Inkjet on canvas, 2009
  48 x 48 in / 120 x 120 cm

Ninty-six maple leaves
  MAPLE LEAF QUILT
  Inkjet on canvas, 2009
  78 x 54 in / 185 x 135 cm

1967
  HABITAT 67
  Inkjet on canvas, 2009
  48 x 48 in / 120 x 120 cm

1982
  CONSTITUTIONAL
  Inkjet on canvas, 2009
  60 x 48 in / 150 x 120 cm

Hundreds of birds
  ALIGHT
  Inkjet on canvas, 2009
  60 x 40 in / 150 x 100 cm

Thousands of caribou
  SWIRL
  Inkjet on canvas, 2009
  60 x 40 in / 150 x 100 cm

Charles's versions of the Group of Seven
  PROP POSITION ONE, 1983
  Acrylic on masonite, 1984
  2 panels, 80 x 54 in / 200 x 135 cm

  EYES SEE
  Inkjet on canvas, 1984
  20 x 16 in / 50 x 40 cm

Strawberry-rhubarb pie
  PIE IN THE SKY
  Inkjet on paper, 2009
  18 x 12 in / 45 x 30 cm